ROD WILSON

Music : Photography : Reportage

Telephone: 250 427 7151
email: rodneywilson1941@gmail.com
blog: www.rodneywilson.ca

THE BEST
CONTEMPORARY
CANADIAN
ART

THE BEST CONTEMPORARY CANADIAN ART

Joan Murray

Hurtig Publishers
Edmonton

Hurtig Publishers Ltd.
10560 – 105 Street
Edmonton, Alberta
Canada T5H 2W7

Canadian Cataloguing in Publication Data

Main entry under title:
The Best contemporary Canadian art

Includes index.
ISBN 0-88830-318-1

1. Art, Canadian. 2. Art, Modern – 20th
century — Canada. 3. Artists — Canada.
I. Murray, Joan.

N6545.B48 1987 709'.71 C87-091320-4

Printed and bound in Canada

Acknowledgements

I am grateful to the artists who helped me make this book. Without their generous participation it would, of course, have been impossible.

Many dealers, curators, and museum directors were also helpful, particularly during the difficult process of selecting the artists; I especially thank William Kirby, head of the Canada Council Art Bank. Robert Fulford and José Druker, old friends of the Robert McLaughlin Gallery, have kindly offered advice. Finally, I send my gratitude to the collectors and institutions who own the works and who have given me permission to reproduce them.

Introduction

This book is an attempt to share some part of the world of Canadian art with a wide group of Canadians. Those of us who have followed the unfolding drama of Canadian art over the last two decades are extremely fortunate. We can watch a stimulating and highly varied exhibition scene in the public and private art galleries, particularly in Toronto, Montreal, and Vancouver. We have an amazing assortment of magazines to tell us about current art, and perhaps we have friends in museums or galleries, or among the artists, with whom we can trade information. There's no Top Ten list in Canadian art, but we tend to know who is creating important work. The audience for that work grows steadily; my hope is that the pages that follow will help it grow further.

The Best Contemporary Canadian Art sprang from the suggestion of Mel Hurtig, who had noticed that no single book identifies what he called the "living greats of Canadian art." He had also noted that friends often complained to him of the difficulty they confronted in understanding recent Canadian art. He suggested that I compile a book that would give the public an idea of what today's artists are doing—their objectives, themes, and concerns; the media in which they work; the directions they see themselves taking in their art.

The range of artistic expression in Canada today is so broad and so varied that a project of this sort seemed, when first broached, almost impossibly ambitious. We decided that the best way to accomplish it would be to show some of the most exciting and most influential examples of contemporary art, as chosen by the artists themselves. Accordingly, I approached one hundred accomplished artists and invited them to participate in creating this book.

When discussing current Canadian art in earlier books and catalogues, I have often used the oral history method. This book extends it: the artists not only speak for themselves, they also selected the art that represents them. They graciously agreed to choose their best work, or some work of great importance to them, and tell me why they chose it. Many of the artists also helped choose (and check for accurate colour) the transparencies used to reproduce their work.

For the better part of a year, I spent many fascinating, stimulating, and occasionally difficult hours talking to and corresponding with these remarkable people, immersing myself in their work, visiting many in their studios, arranging for the photography of their selections. For me the experience was immensely rewarding. I am fascinated with the broad course of contemporary Canadian art; in nineteen years with it, I have closely watched the changes in the speed of its current, not to mention its rapids and gently spinning pools. Even so, much of what the artists were saying about their work was new to me and I found myself noting their words as much for my own interest as for the enlightenment of the reader.

The comments that accompany each plate are a distillation from many hours of interviews and discussions with the artists. In an important sense, of course, the artists are saying all they want to say in their work. Many artists (including some in this book) feel very strongly about this and are either

unable or unwilling to translate their ideas into words. I respect this philosophy, although I believe that verbal comments can often provide valuable insights and a personal dimension that enhance appreciation of the work.

For people not trained in the idiom of art, modern art—and especially abstract art—*is* difficult to understand and may at first seem impenetrable. Yet one of the hallmarks of good art is its universality—a deeply personal creation that at the same time speaks to something common to all humanity. No doubt trained critics and artists appreciate works of art in a way different from the general public, but I feel confident that everyone will respond at some level to the work featured here. This book is not intended to be a critical review; rather, it is a homage to one hundred Canadians making the best art in Canada today.

The choice of the artists was mine. Needless to say, it was a difficult task, and presumably many will quarrel with my selections (or more likely with my omissions). The initial criterion of eligibility was arbitrary: I considered only artists of Canadian citizenship who are still alive and working. After this, the most important factor was quality. With artists whose work is known by its subject matter, such as Robert Bateman, I sought the art within the content.

Two anthologies to which I had contributed previously helped guide my selection: *Contemporary Photographers* (1982) and the second edition of *Contemporary Artists* (1983), both from St. James Press in England. For these books the featured artists had been selected by international advisory boards, and their perspectives helped me to see Canadian work in an international context. I was an adviser for Peter Mellen's *Landmarks of Canadian Art* (1978), for which I wrote many of the entries, and I also served as a consultant and writer for *The Canadian Encyclopedia* (1985). These books were especially important in helping me appreciate the standards of excellence Canadians have developed. In assessing the level of achievement, I considered power of expression and technical mastery of medium important.

I also decided that in addition to having produced work of exceptional quality, the artists should have exhibited in major galleries, should be represented in the collections of major museums, and should have worked as professionals for at least ten years. "Only persist," Ivan Eyre once said to me as he explained his own career. It was important to me that the artists I selected had stayed in the field or, if they had left for a time, had returned to create a new exhibition history. I greatly admire persistence. But persistence, if it results in boring art, is not enough. I looked also for brilliance, vitality, inventiveness. The reader may well detect personal idiosyncrasies of taste, perhaps including some of which I am not altogether aware.

Painting and sculpture have dominated the visual arts in Canada in our time, so they naturally dominate this book. Drawings and watercolours also play a role, but a smaller one. In the more recently developed forms—such as holograms, performance, and video—I have chosen pioneer figures who have

been at work for the last decade. I hope that the individuals who speak and show their work here interlock into a rough history of Canadian art in the recent past, especially since the 1960s.

While making my choices I tried to maintain a national focus. I worked on the list until it seemed to encompass the main issues in recent Canadian art history. These issues I see as the acceptance and development of abstraction, then of contemporary figuration and the new technologies. The opening up of the field to include the surrounding space of the environment is also important: in sculpture I thought of Ian Carr-Harris, in performance Tom Graff. I thought of the book in musical terms, as the statement, development, restatement, variation, and elaboration of a number of themes.

My method of selection has its faults, of which I am all too aware. The artists chosen are those who seem likeliest to have a lasting influence, but even in that group not all are represented. The omission of certain printmakers makes me feel most uncomfortable, and if the list could be longer printmaking would certainly be better represented. Readers familiar with art galleries in Canada will notice other striking omissions. The marvellously vital and inventive Inuit and Indian artists, for example, are not here; in my judgment they do not influence, and are not influenced by, most of the artists this book features. Inuit and Indian art need to be treated separately, as they often are, because of their different cultural background and objectives—though perhaps one of my successors, a century or so from now, will decide that Kenojuak was the most compelling artist of Canadian citizenship in our time. I have also set crafts and folk art aside, for parallel reasons.

Canadian art today is in a state of flux. In the work of young artists today I see a tremendous growth along lines I have stressed—new formal concerns as well as new themes and procedures; sculpture spatially oriented in dispersed units, combined with the possibilities of technology, video or light. Multi-media art has a new reality in reference to its various parts. Presentation has changed, become more active. I see more politicized work, work which engages the viewer in a more demanding relationship. Equally, I see work with references recognizable but evanescent, work which curls around the imagination like a haiku poem. At the same time, as some sculptors continue to react against the monumental tradition, others build new monuments, a return probably to yesterday's massive, architecturally related sculptures. I see higher technical quality because art schools are training students better. The artists in this book are at the forefront of these developments. Only time will tell whether they will be seen as progenitors or as transient figures, interesting during only a limited period.

The book will serve one of its purposes if it simply helps newcomers to contemporary Canadian art. But I hope, too, that the thoughts of the artists gathered here will help even the most seasoned collectors and art-lovers deepen their enjoyment of their favourite artists.

Joan Murray

Artists and Works

Had I the hand for form and line,
 The soul-selected best,
No time to paint that plumy pine
 Against the broken West.

Or could I take it with a thought
 And press it in a book
For all to see the trees that stand
 When Spirit turns to look.

J.E.H. MacDonald, "Quick Sketch"
from *West by East* (1933)

Barbara Astman

b. 1950, Rochester, New York

My favourite piece, although not necessarily my best
piece, is *Antwerp by Starlight*, from the *Places* series,
first shown at the Sable-Castelli Gallery in 1982. I went
to Antwerp in 1981, arriving in the evening as the stars
were growing visible in the sky. My initial reaction to
this vision—not so much my experience from spending
time there—is recorded in this piece. The black and
white speckled tile in the background acted as a memory
trigger to that specific vision.

The visual memory the work provides of entering
into a situation that is colourful and rich, vaguely famil-
iar but also confusing, appeals to my sense of controlled
adventure. The emotional memory has been coloured
with time, and now feels as though it should be more
sober. The piece talks of the magic of somewhere else,
that initial reaction to something new, something unex-
pected and possibly exciting.

Toronto, Ontario

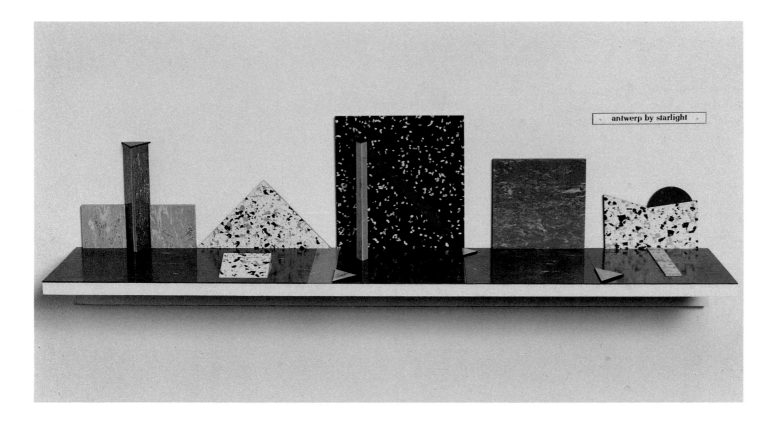

Antwerp by Starlight (1982)
Mixed media construction (linoleum, wood, plastics)
20.3 × 105.4 × 22.9 cm
The Nickle Arts Museum, University of Calgary, Calgary
Photograph courtesy of The Nickle Arts Museum,
University of Calgary, Calgary

Robert Bateman

b. 1930, Toronto, Ontario

I had wanted to do this picture for a long time before I found a genuine old nineteenth-century railbed that had been left alone so that nature could act on it. Abandoned railway lines often provide nesting sites for killdeer; the moulded pebbles fit the mother's breast and provide perfect camouflage for the eggs and young. The young killdeer, like the shorebirds to which they are related, are precocious and can run about shortly after hatching. The delicacy of the little bird contrasts with the heavy power of the railway ties and tracks, yet he fits perfectly in this man-made environment.

My goal in painting is to capture a moment in time that could have happened. I assemble the artistic elements from different sources and attempt to give a totally natural and casual look. In other words, like a Japanese garden, the work is contrived to look uncontrived.

This painting is a typical example of a piece of nature—with a very ordinary and even slightly ugly railroad track and railbed; a bird which is very difficult to see; and even a humble dandelion.

<div align="right">Vancouver, British Columbia</div>

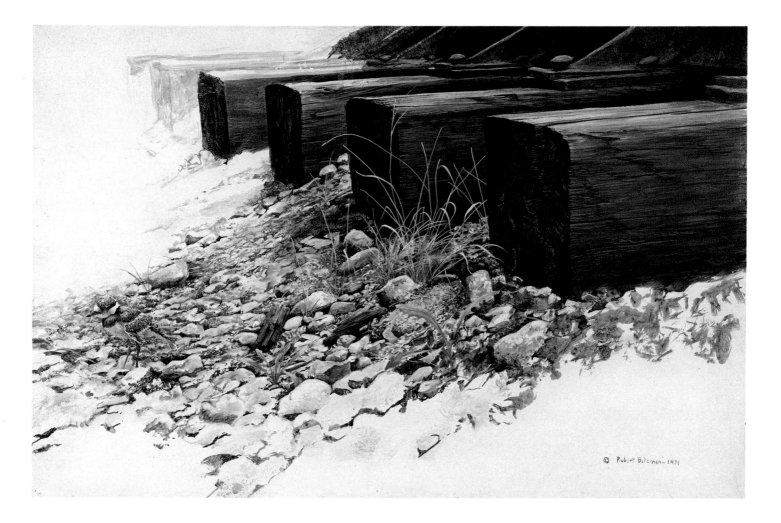

Killdeer by the Tracks (1971)
Egg tempera on masonite
45.1 × 63.5 cm
Private collection, Vancouver
Photograph courtesy of Mill Pond, Venice, Florida

Douglas Bentham

b. 1947, Rosetown, Saskatchewan

I have always asked of my art that it breathe for me, that it engage the viewer in an intimate, instinctual way. The sheer openness of the prairie, the environment in which the majority of my sculpture is created and first displayed, is imposing. To hold its own in this space a sculpture must display a firm conviction for position, for presence—a visual stability and place.

My work comes as a stream, each new sculpture building on the last. Whatever form or scale the objects may take, the best of them display an "aesthetic surprise" (call it ambition) from which I, the maker, and you, the viewer, can grow. Think of the experience as being like a room with many doors through which to enter or exit.

I like to have my sculptures around me so that they can "talk to each other"—to agree or criticize—and in turn inform me of their strengths or weaknesses. Steel collage allows me great freedom to alter and improve upon an individual work—"to bring it up" to a level shared by the others.

Out of all this there are still bound to be favourites, the ones that won't leave you alone. *Mesa* is at once forthright and elusive. It—actually, more of a *he*—stood, sat, and lay in our pasture (my summer work site) for the better part of four years. He never jumped right out and said, "I want to be this, or that" but there was never a doubt that he was deserving of continued attention.

Next he was to go through a pampered stage—on display with several of his kin within the rich, textured ambience of the art museum. During installation he demanded to be positioned first, the others situated with him in mind. Lifting equipment would be employed and backs would be strained until he, still stubborn, melded with the others.

From one viewing position he can appear heavy and somewhat ponderous, from another, light and even gentle. From one angle he is generous, back elements sweeping around toward you. Yet move a few feet one way or the other and he'll make you walk all the way round. He can be inarticulate and even ugly, then poised and quite beautiful.

His final stop will be an outdoor public setting in conjunction with a fine new building in Hamilton. His surface will no doubt darken (he prefers *mellow*) from urban pollutants. He has a bench-like element perfect for a lunchtime seat—and this he can tolerate. But he's not a billboard or a refuse bin. He is what he is, a new way of looking. No more, no less. I'm sure he'll meet with criticism—the physicality of abstract public sculpture often brings out the worst in people—but he'll do alright.

mesa (ma'sə) n. (Sp. < L. mensa, table) a high plateau with steep sides. I liked that for a title, something big about it. It suited him.

Saskatoon, Saskatchewan

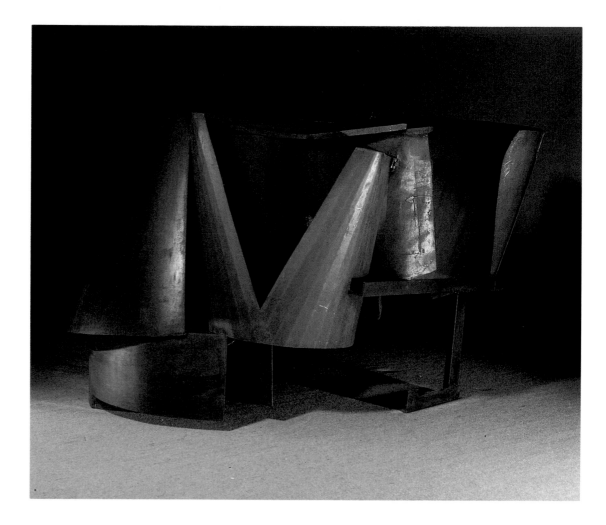

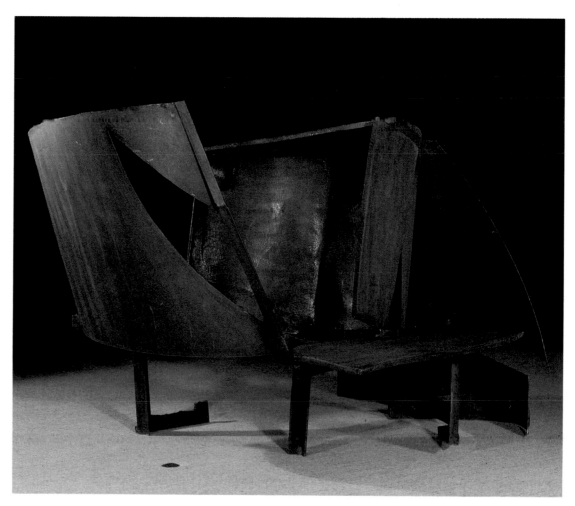

Derek Michael Besant

b. 1950, Fort Macleod, Alberta

Much of my subject matter is very pedestrian, so for my exhibition at Canada House in London in 1987 I decided to work with materials as pedestrian as my subjects— cardboard, tape, string, etc. Two recent series, *Diagrams* and *Sites*, sought to exploit the existing paraphernalia that surrounds us and were characterized by a practical use of line, by simplicity, and by unification of form and technique.

Communication may have to take place through the peripheral structure of our surroundings. Uncontrived subjects are often the most consistent things we encounter on an everyday basis—by these I mean the pile of lumber that appears at random on any construction site, the propped up accumulation of wheelbarrow, bicycle, and garden tools in the backyard, or the temporary mountain of baggage in the airport. These occurrences, often transient, happen with such regularity and consistency that we tend to regard them as without aesthetic merit. However, these conditions seem to be a part of my life and, being inescapable, are assimilated into my studio work. This is perhaps the most appropriate artistic response to our environs.

The *Sites* series, despite its predominantly utilitarian character, contains the formalistic properties that the *Diagrams* series embraced. At its most reductive, it arrives at a synthesis of subject and technique that yields an architectonic form. Once such work would be the drawn, bent, folded cardboard construction, *A-drift*. I have done several works that have included canoes; it would seem that the canoe tends to be a Canadian icon whether it is found on top of a car rack, leaning against a fence, or pulled up on shore. It is a form I have always responded to in a visual perceptual sense.

A-drift (although I never consciously planned it) has always felt like a nocturnal piece to me. It is about surface tension and structure, both theoretical and visual, and is one of my best confrontations.

Calgary, Alberta

Sites/A-drift (1986)
Charcoal, tape, and chalk on cardboard
152.0 × 242.0 × 10.0 cm
Mira Godard Gallery, Toronto
Photograph courtesy of John Dean, Calgary

David Blackwood

b. 1941, Wesleyville, Newfoundland

I'm a printmaker and this is the biggest plate I've ever done, thirty by thirty-six inches. It's a combination of many things I have used for the last twenty years, a summation of subject matter and technique. At one point I thought it was fully realized but deep down I felt there was something incomplete. A lot of works have that feeling, though, so I went ahead and included it in a show, framed. But it started to bother me and I withdrew it after ten copies of it were sold. Historically, of course, you would refer to those prints as "the first state." After I withdrew it I worked on it for another six months, producing a second and final state. The first and second states make up the total edition of fifty prints.

In this plate I was thinking of my father and his dreams, going back to his childhood. I grew up listening to old people speak of their dreams about their earlier lives. This was part of the storytelling tradition. The dreams became a part of reality and the reality became a bit of the dream. In this plate somebody in his seventies or eighties is in a chair or in bed, thinking about childhood or youth. Father and son are in a boat, and in the background you have this shape, which could be an iceberg or something else; it's open for interpretation.

I'm the boy in the print and the man is my father. He's in his seventies and it's a tribute to him in his last years. It's his environment—the whole sea is there and the sky. I plan to do a whole group of prints on the idea of the dream. The work will become simplified and perhaps more abstract, moving more and more away from specific realities. Things will be floating around.

After a year and a half of working on the plate, actually about thirty-five stages in all, I felt it finally reached a point where it was fully realized. I've learned from doing this piece of work. I've rediscovered certain things—there was an accident in this work from which I learned. The sky area in this print, behind the great looming shape in the background, was very light at one point and I decided to darken it a little bit; it really became *extremely* dark, and it was a bit of a shock but it was fantastic. All of a sudden, the whole thing started to float in space and that's what I wanted.

Port Hope, Ontario

His Father Dreams (1985–86)
Etching (impression)
91.4 × 76.2 cm
The artist, Port Hope
Photograph courtesy of Helena Wilson, Toronto

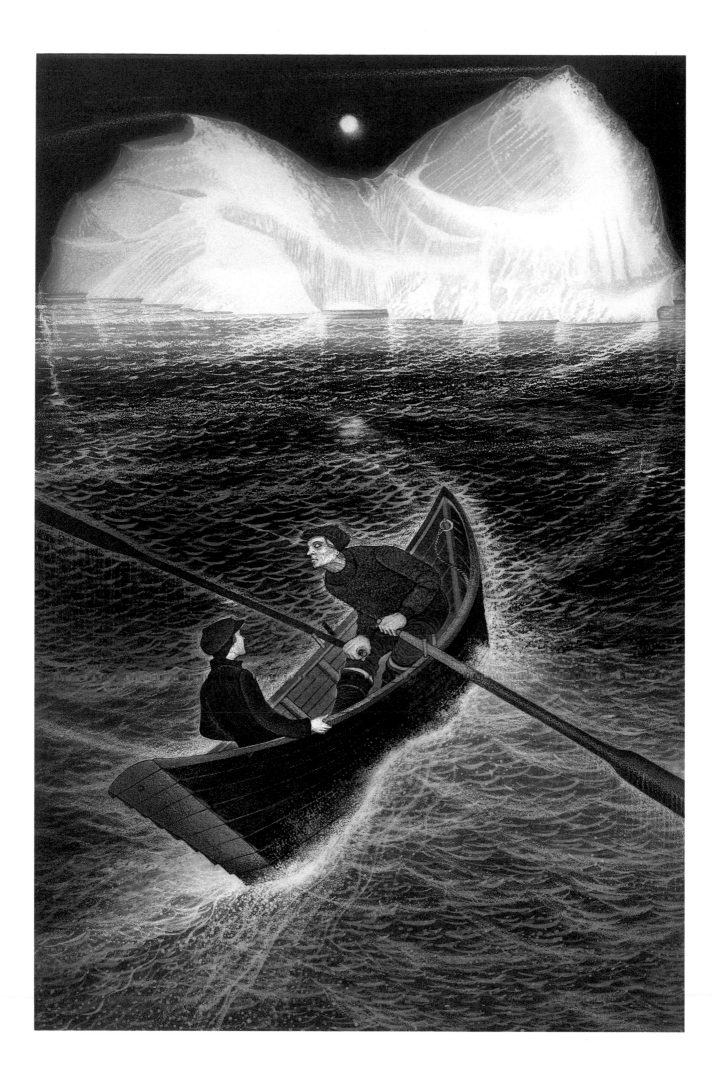

Ron Bloore

b. 1925, Brampton, Ontario

The *Chasuble* series of paintings, related panels, maquettes, and a few drawings developed after a 1982 trip to England. One morning while revisiting the Victoria and Albert Museum I passed by some unimaginatively displayed chasubles. I turned back, fascinated by their ancient simple shapes and intrigued by their sensuous textured surfaces. They evoked a curious memory of another piece of liturgical weaving, the Epitaphios of Thessaloniki, in the Byzantine Museum in Athens. At first sight this fourteenth-century work is dull, grey, and boring: dull and grey because of the many tarnished silver threads. But this once rich and richly woven depiction of the dead Christ, with mourning angels, apostles and evangelists, is a deeply moving work.

For me, my most rewarding recent work is the first of the *Chasuble* series, a 1983 painting in oil and spray enamel. After three horizontal lines were raised on the hard masonite panel, white oil paints were scratched with gently tapering Japanese chopsticks. The importance of this work lies in the coalescing of diverse visual experiences and a new naive technical expedient to redirect slightly the form but not the content of my work. It was a beginning.

For years I have been concerned with establishing a low-relief image in oil paint on masonite, at times spray enamelling certain surfaces or glazing other areas. The paints are normally spread, raised, and shaped by flexible paint scrapers. The Japanese chopsticks are the latest addition to my working tools. The paint is thinly layered with the scraper and then stroked through rapidly at varying angles with the chopsticks. The direct result is a visually very active surface. There is no one way of seeing these works. Changes in lighting conditions or the viewer's movements shift the surface patterns, and the painting is transformed.

This work—the first to resolve some basic problems—initiated an ongoing series bringing together ideas I had been probing for several years: assembled shaped panels. Assembled panels permit the construction of paintings beyond the four-by-eight-foot commercial limitation of masonite and plywood. Years later, I'm still expanding upon the simple technical and formal solutions released by this particular painting.

Toronto, Ontario

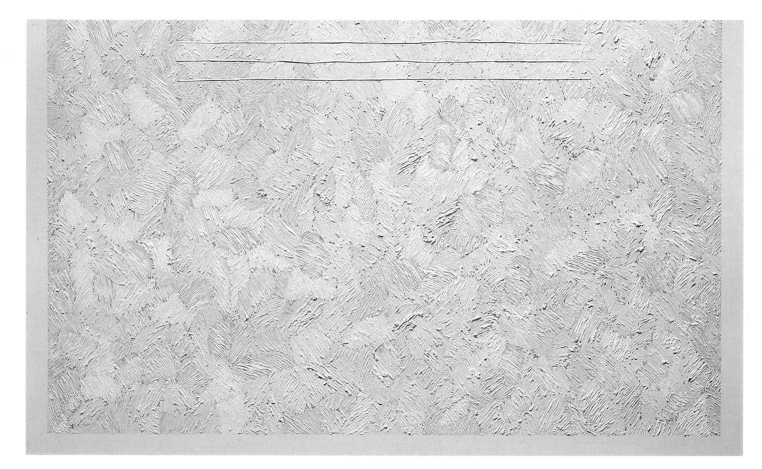

Untitled, Chasuble Series #1 (1983)
Oil and enamel on masonite
121.9 × 198.1 cm
The artist, Toronto
Photograph courtesy of Tom Moore, Toronto

Bruno J. Bobak

b. 1923, Wawelowska, Poland

I am very interested in people as individuals, and I am more interested in their personalities than in their appearances. When I paint a picture, I try to bring out the human qualities of the sitters—problems, anxieties, feelings of tenderness, weaknesses, compassion—not so much in their physical appearance but more in the manner in which they are painted—colour, form, symbols, etc.

Even when I paint a portrait, I try to paint a personality—partly the sitter's and partly my own—more so my own, perhaps, since the subject is only a vehicle for communicating my feelings.

I feel my pictures have to tell a story, and the expressive manner in which the picture is painted must be an inseparable part of this story, as this is the basis of Expressionist painting. It is only natural that I learned a lot from Munch, but even more so from another Norwegian artist who had a greater influence on me, Gustav Vigeland.

By nature I am a very passive person—I shy away from groups, causes, and mass protests. I tend to look inward, and with my inner perception I paint the things I feel, but without a specific message. My paintings are full of contradictions. They are the personal struggles of men, women, and children in conflict with their complex makeups, sometimes tragically funny, sometimes bewildered and pathetic.

Somehow all this confusion seems to disappear when it is arrested onto a canvas and becomes a formal statement. The themes of my paintings are so simple and so basic that the satisfaction comes from searching for new ways of expressing these simple themes and from trying to do it just a little more forcefully with each succeeding canvas.

It is difficult to write in general terms. Let me describe this painting as I conceived it. The painting is called *Comfort*. The picture shows only a figure curled up in the arms of another figure. This is the picture, but it is not the whole story. She is being embraced in an extremely tender way. What we have is a yearning for comfort, for love, for security. This painting represents more than an embracing couple; it is the story of life. She is craving the comfort of her mother, her father, her lover. This is all represented by the infant-like form that she sits in, in the warm tones of tenderness that she is painted in, and the soft fluid lines.

He manages to embrace her completely. He is comforting her, understanding her, consoling her, keeping her warm as though she were a bruised child. He is not handsome, but he is comfort. There is compassion. There is also passion, represented by the use of warm reds in a cold blue and grey outer world. There is hope in the gesture of his searching eyes, and strength in the powerfully embracing but gentle hands.

The composition is an oval. It is a nest, an egg, a womb. They are naked. The two figures are one.

A very simple theme—but so big and universal.

Fredericton, New Brunswick

Comfort (c. 1965)
Oil on canvas
152.4 × 101.6 cm
Jerome and Christina Sabat, Fredericton
Photograph courtesy of the artist, Fredericton

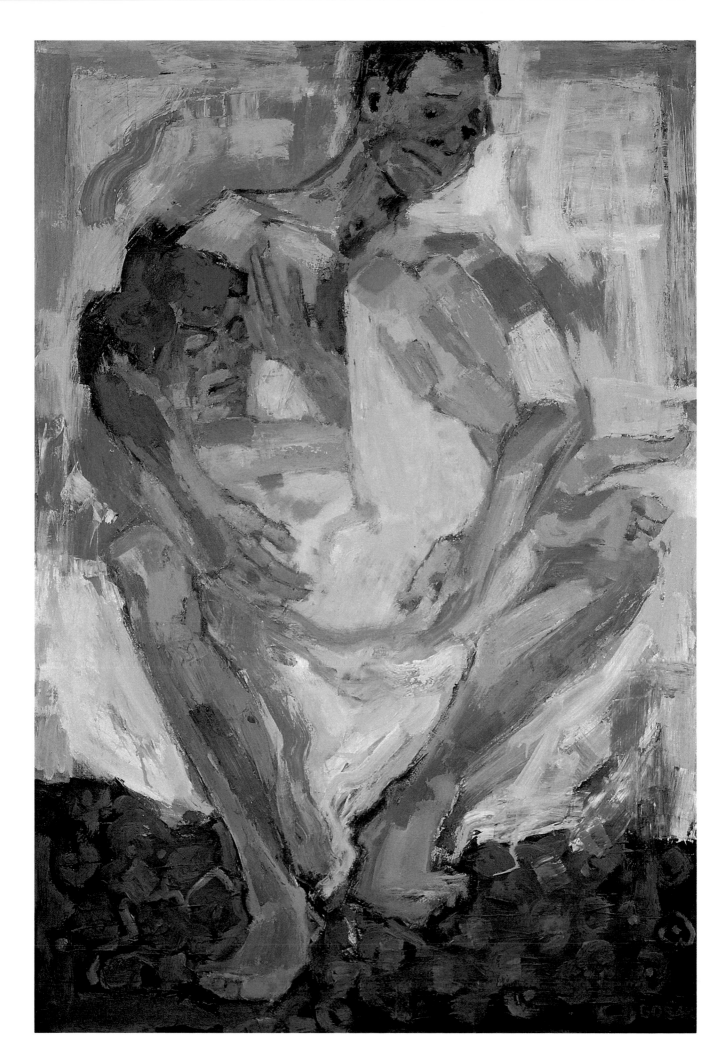

15

Molly Lamb Bobak

b. 1922, Vancouver, British Columbia

I have always been interested in informal movement—
blowing wild flowers, parades, protests, crowds on the
street, crowds anywhere; just as long as they turn into
painting space in my head. The subjects which most
motivate me have a certain impersonal busy-ness, as if
we, like the flowers, are waving about at random. I see
these relationships quite by accident (I never consciously
seek them out). Immediately, a canvas or watercolour
forms in my head. The great trick, of course, is to trans-
late the concept onto the canvas without losing the
vitality one first felt. The Ball at the Legislature was held
here in Fredericton in 1985 as part of New Brunswick's
bicentennial celebration. Some guests wore Acadian
costume, others Loyalist costumes. They made the
dance very amusing and colourful. I made sketches from
the balcony of the Legislature (turned into a ballroom for
the evening) and painted several versions over the
following months.

Fredericton, New Brunswick

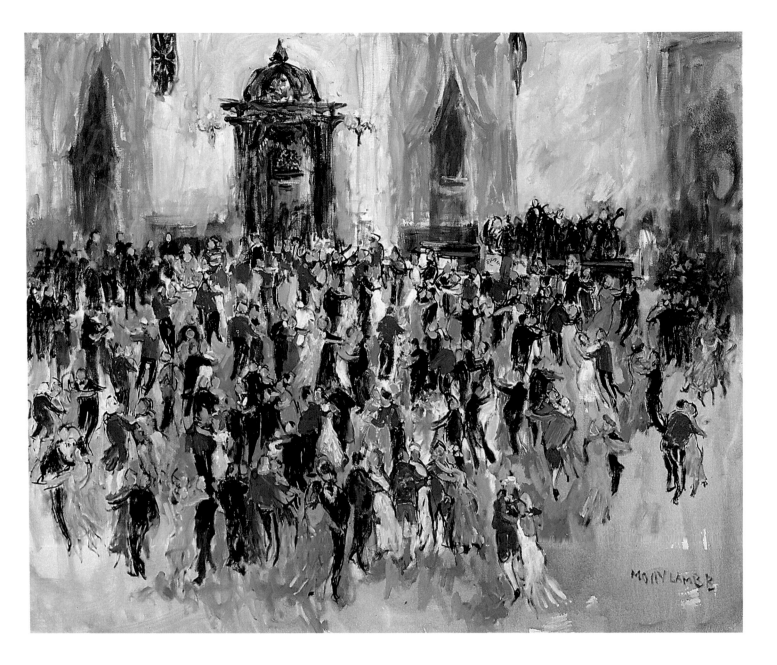

Ball at the Legislature (1985)
Oil on canvas
101.6 × 121.9 cm
Mr. and Mrs. Harrison McCain, Florenceville
Photograph courtesy of Saunders Studio Ltd., Woodstock, N.B.

David Bolduc

b. 1945, Toronto, Ontario

I've spent most of the last three years living in the country and this has determined to a great extent not only what I see, but how I see it and consequently how I think and what I think. This painting is one result of this situation. In other words, it is close to the way I've been feeling about certain things lately. It was painted shortly after a trip to Rhode Island last April. The early spring there was welcome after grey Montreal.

Toronto, Ontario

Maroc (1986)
Acrylic on canvas
228.6 × 213.4 cm
Klonaridis Inc., Toronto
Photograph courtesy of Tom Moore, Toronto

Robert Bourdeau

b. 1931, Kingston, Ontario

This image encompasses the concerns I am deeply involved with in my camerawork. My initial response to this subject was to register the force and confrontation of the rock walls, the delicacy of the trees, the radiant light, and the structure which unified it all. However, at the level of seeing at which I work the subject matter often becomes secondary to greater meanings: inner luminosity emanating from the subject, abstraction of scale and the picture space, ambiguity, an hallucinatory amount of detail, tension, confrontation, and reconciliation. The images become tapestries where areas of space are filled with minutiae that function within the whole context of the picture, and the entire surface of the print has a life-force of revelation, lucidity, and plenitude—a visual/emotional completeness, a fully realized image.

My photographic quest is not just earth, water, rocks, trees, flora, sky, buildings, but the rhythm that flows through and beneath all things and that abstracts, transforms, and transcends until "other" things are confronted and seen. The photograph becomes a place from which to journey through a landscape behind a landscape with its mystery, force, presence, and spirit.

Ottawa, Ontario

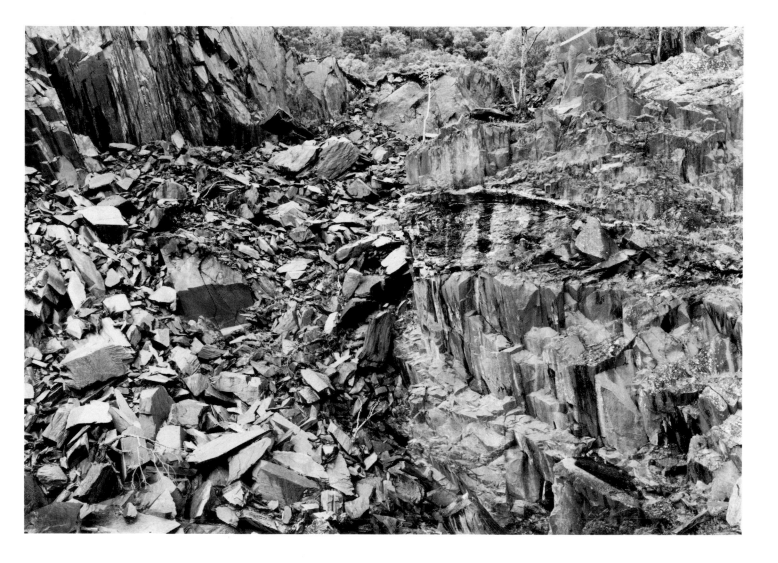

Cumbria, England (1985)
Gelatine silverprint
27.9 × 35.6 cm
The artist, Ottawa
Photograph courtesy of the artist, Ottawa

John Boyle

b. 1941, London, Ontario

The most recent works are the ones you care most about. My most recent series I made for a Belgian show—inner linings to a Plains Indian tepee, three sections, a large work. I also like the tepee that I did before that, a full-size Blackfoot tepee the National Gallery bought.

I was fooling around with things that used canvas or fabric, and that also had a tradition of being decorated. The tepee was a natural. I stumbled upon it accidentally while doing some research about the Riel Rebellion. I saw a drawing of the outline of a tepee, the pattern, and it was a beautiful shape in itself. I did a print where the image was contained within this tepee pattern. Then I realized that if I cut out the pattern and folded it up, I would have a little tepee. I did it. Then I made a big tepee and painted on it, in a natural flow of ideas. On the actual painting on the tepee, I departed from the traditional Indian approach, although there are Indian elements in my imagery. I maintained my own personal integrity but I don't think I defiled the Indian tradition.

On the sides I painted an image of the late Carl Ray, the Ontario Indian artist, and an Indian child from a magazine photograph during the James Bay construction business in Quebec—an image of a kid whose land was about to be flooded so that we can sell power to the States. They were the Indian elements. There was another animal, a bison, that I saw in a zoo in Hamilton.

What else is on there? Two canoes, both of them with Indian families, from old photographs. The landscape is the Niagara Escarpment at Cape Croker, where there's an Indian Reserve. The tepee doors became a series of portraits of people like Norman Bethune and Ray Woodworth, my late friend who was an artist, and Joshua Slocum, a Maritime mariner, a very interesting character. I did eight of those portraits. They were personalities and images that were important to me, and they held together. They appeared to have a connection between themselves within the piece, which is a bonus in my work; it's not usually there by design.

The piece is sixteen feet high. That's at the small end of the scale for Plains Indian tepees, but when it's shown indoors, it's mammoth. That conical shape is a wonderful design for a tent. I slept in the work a couple of times when it was in my studio, and it is a magical kind of thing. Everything was nice about that piece, for me. People respond to it as well.

Elsinore, Ontario

Cape Croker (1977–79)
Acrylic paint on canvas
Base 4.45 × 4.14 m; height approx. 5 m
National Gallery of Canada, Ottawa
Photograph courtesy of the National Gallery of Canada, Ottawa

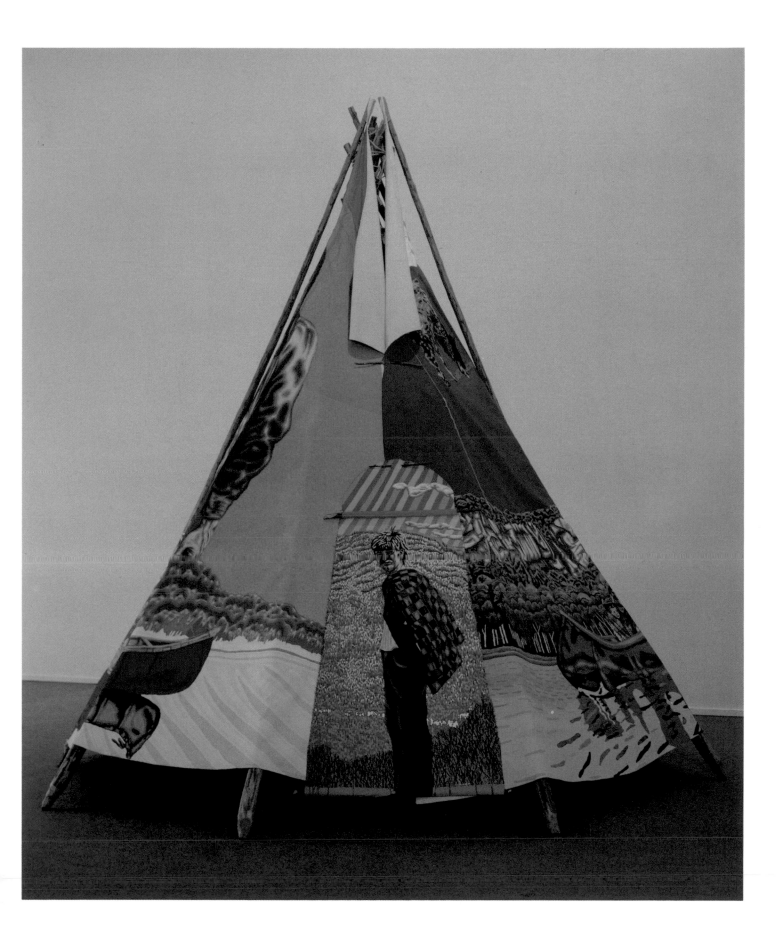

K. Jack Butler

b. 1937, Pittsburgh, Pennsylvania

Shadow is a theatrical assemblage combining posters
from popular culture with images made by the tradi-
tional process of high art. A critique of violence, it repre-
sents "...the still intrinsically precarious situation of
the human itself in the technical world...vulnerable
body is the substantial metaphor" (F. Pellizzi in *Parkett*
(1986), p. 45).

The spectator participates in the room-sized tableau
as the integrating factor that brings together extreme
opposites in subject matter, such as cinema posters of
Rambo and Marilyn Monroe versus private portraits of
the artist's family. Opposites occur also in terms of
scale: tiny translucent X-ray images of nude bodies
versus twice-life-sized ghosts of superheroes. Sensuous
materials, silk tissue White Goddesses, are opposed to
steel masks. Radical discontinuity characterizes the
content, and a dream-like evocation of wholeness
surrounds the painterly process with a halo of multiple
meanings.

Winnipeg, Manitoba

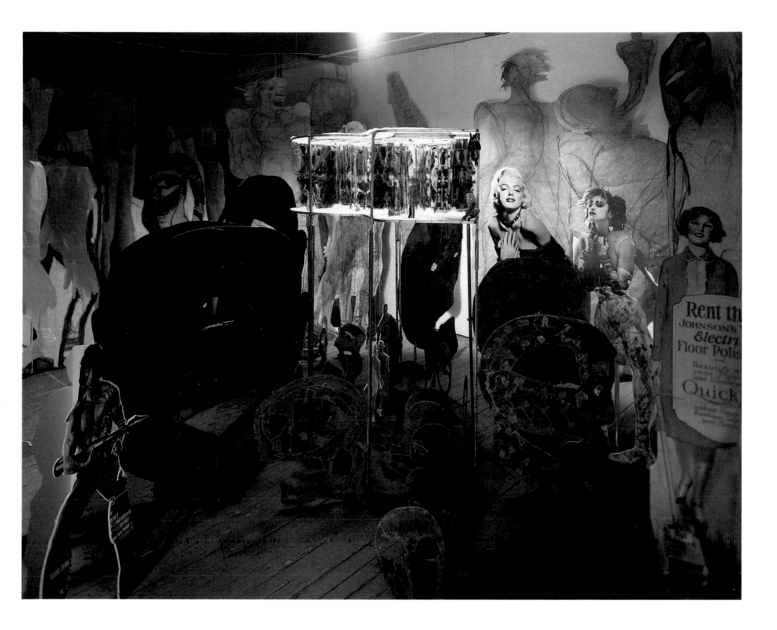

Man Is Only the Shadow of a Dream (1985–86)
Mixed media installation
10.7 × 10.7 × 3.4 m
The artist, Winnipeg
Photograph courtesy of Garry Allan, Winnipeg

Sheila Butler

b. 1938, McKeesport, Pennsylvania

Drawing for me is most often a way of thinking about painting, and this is true of *The Apartment*. This work combines a reportorial view of the *mise en scène* (expressed by a cool, rather unvarying line) with dream-like, multi-layered human figures. A superimposed change of scale suggests the illusion of physical movement through space.

This drawing is from a body of work which seems to represent a turning point for me, resulting to a great extent from a change in my attitude to the use of narrative. Although I have previously professed a lack of interest in narrative elements, my drawings led me through a natural evolution to a concern for narrative. In *The Apartment* I attempted to suggest a narrative, without reference to a verbal plot line or a linear progression. I suggested relationships which each viewer may deal with individually.

In another departure from previous practice, visual sources were extended. Photographs from a news magazine provided the human figures, to a large extent altered by adaptation. The setting—walls, furniture, etc.—was drawn directly from the subject. Other aspects of the image came from memory and imagination. This collective approach consolidates individual experiences, originally separated by time, and offers me new insights into content.

The figures are much smaller in relation to the size of the rectangle than has been customary in my previous work. The larger areas of white paper provide space for the figures to move and live their own drawn lives.

As form alters to meet the demands of a newly perceived depth of meaning in the subject, one becomes aware again that for a painter at a time of transition, drawing can be a useful tool. As I wrote in a recent catalogue essay, "On paper, marks are laid down with more ease than on canvas. Alternate thoughts may be captured more quickly before the mind and imagination outdistance the speed of the hand's physical movements." (*The Eighth Dalhousie Drawing Exhibition*. Halifax: Dalhousie University Art Gallery, 1986.) For me, this happened in the drawing presented here.

Winnipeg, Manitoba

The Apartment (1986)
Graphite and India ink on paper
190.5 × 152.4 cm
The artist, Winnipeg
Photograph courtesy of Wes Pasko, Winnipeg

26

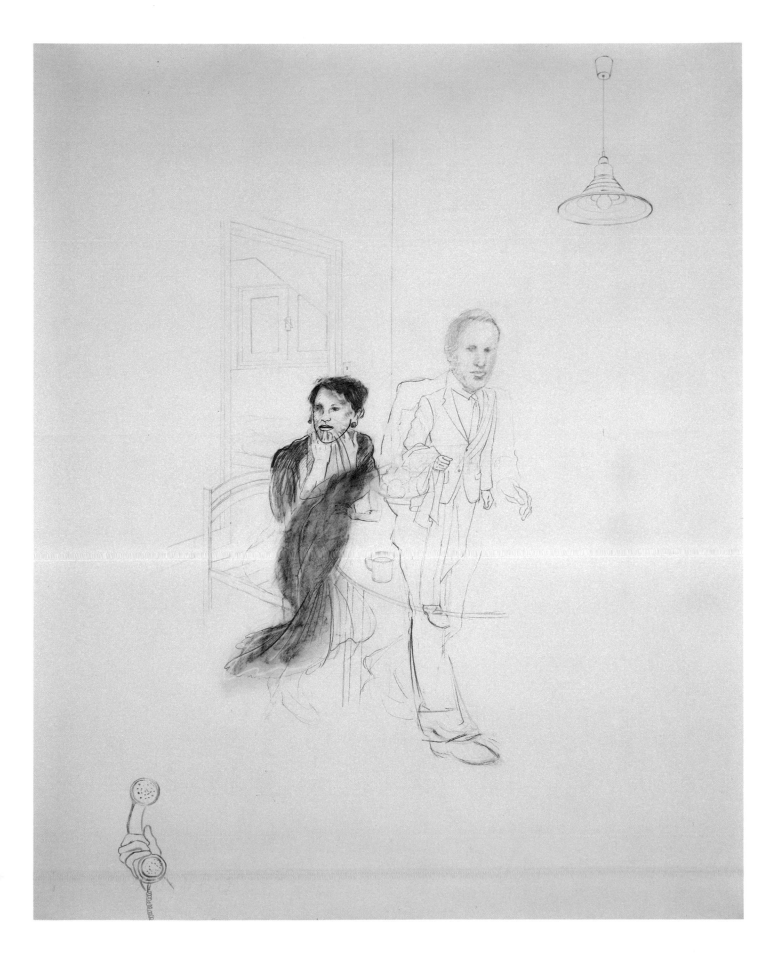

Alex Cameron

b. 1947, Toronto, Ontario

I like *Blue Strawberry* because the colours are perfect.
The contrast between the off-red and the intense blue is
extremely beautiful for me.

Toronto, Ontario

Blue Strawberry (1976)
Acrylic on canvas
167.5 × 167.5 cm
Private collection, Toronto
Photograph courtesy of Tom Moore, Toronto

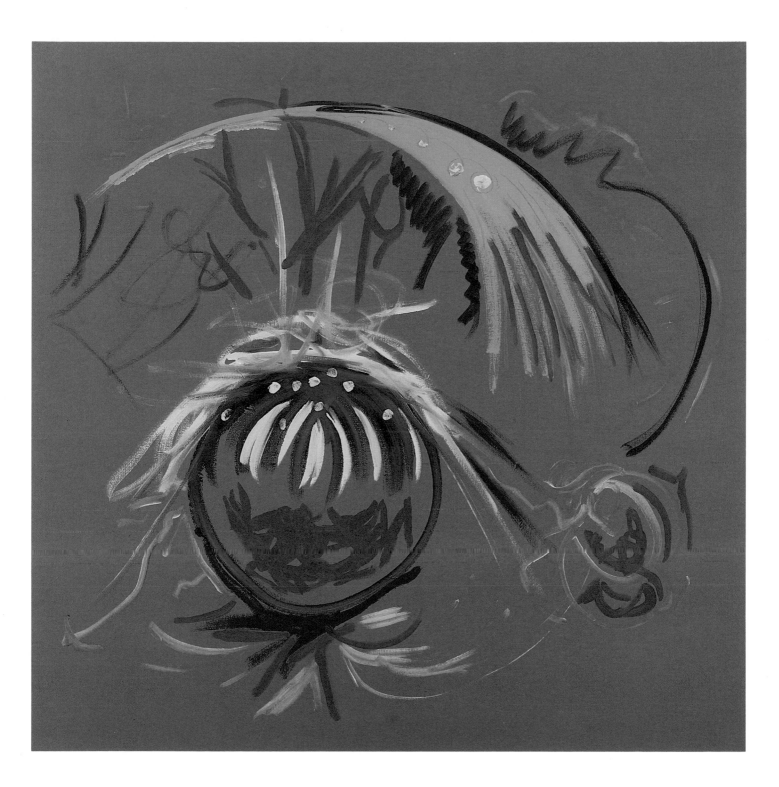

Ian Carr-Harris

b. 1941, Victoria, British Columbia

"From time to time I've discovered that implication and suggestion have their limitations. Or perhaps to put it more correctly, that if you want to say something, it is better to be quite straightforward.

"This brings me to the work you see here, one concerned primarily with two distinct orders of consciousness—sacred and profane—and the distances, or paradoxes, which differentiate them. And it chooses a traditional means—picture and story—to do so.

"It is clear that the work's underlying thesis is that the difference between intention and action is the difference between knowledge and justice; that we know far more than we admit to, and that if Justice is blind, it is not in order to be impartial, but to separate these two irreconcilable states of being from each other.

"The inherent vulnerability of the woman's position—cupping her outstretched hands to hold out something for us to see—inevitably invites a choice within ourselves—whether we care to acknowledge it or not—a choice which pits our deep consciousness of that vulnerability against our curiosity about the world. And if reality can be said to exist, then it exists within the struggle between these quite opposing desires."
(Quotation from one of the five spoken texts within the work.)

Toronto, Ontario

5 *Explanations* (1983)
Painted constructions with special lighting
and audio voice-over
Dimensions variable; as installed here: approx. 455 cm across,
760 cm long, 210 cm high at screen
Canada Council Art Bank, Ottawa
Photograph courtesy of Centre de Documentation,
Yvan Boulerice, Ottawa

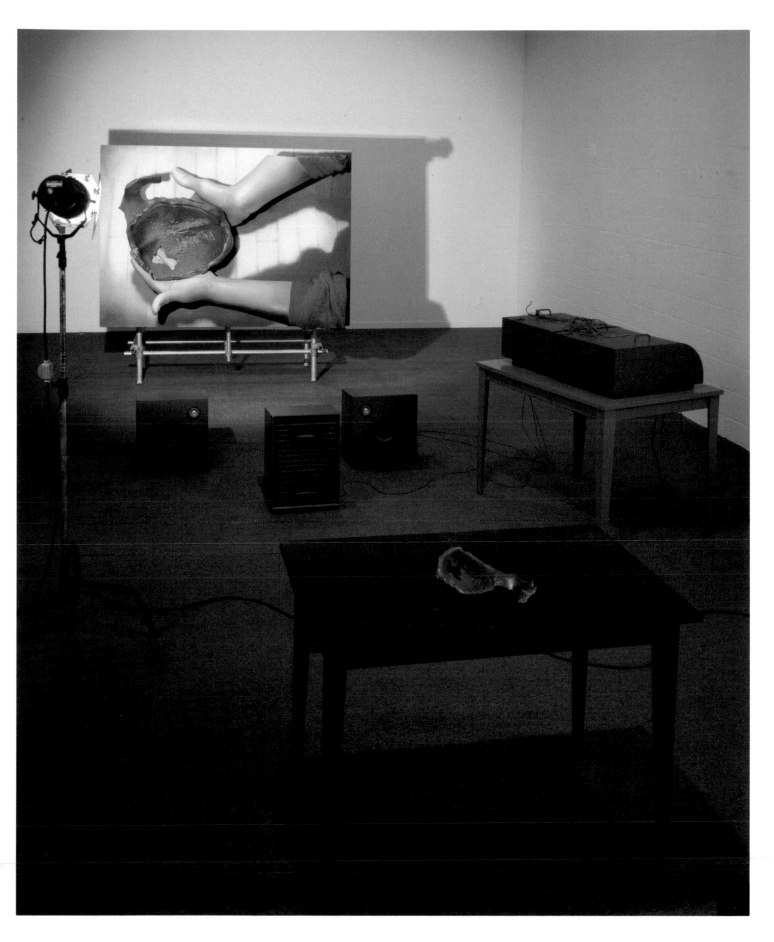

Alex Colville

b. 1920, Toronto, Ontario

I did *Seven Crows* in 1980. It's based on an actual area around Wolfville, although I've taken some liberties with it. The painting, oddly enough, is related to a newsreel that I saw probably in 1940 or 1941, in which German bombers were flying past, I think, Oslo. I know it's related to my having seen that. And the painting is also an illustration of a child's nursery rhyme which you may know:

> One crow, sorrow
> Two crows, joy
> Three crows, a letter
> Four crows, a boy
> Five crows, silver
> Six crows, gold
> Seven crows, a story
> Never to be told.

I like the "never to be told" business because all visual art has what has been called "unspeakable content."

Many paintings are summations of different periods in one's life. This work could be called a summation in that I've done a lot of things with birds and this is one of the most satisfactory ones.

I've always wanted to be able to fly—although, of course, as a human being this is impossible. I can't just take off from the roof of a garage or something, and my fascination with birds is part of that. My friend Robert Hubbard, the former chief curator of the National Gallery of Canada, once said to me that birds tend to appear in art at times when human affairs don't seem to be in very good shape—as in the fourteenth century, say, or now. What he was saying was that men and women look at birds and admire them and vicariously experience what it would be like to fly. Not with machines—that's another matter—but real flying.

Wolfville, Nova Scotia

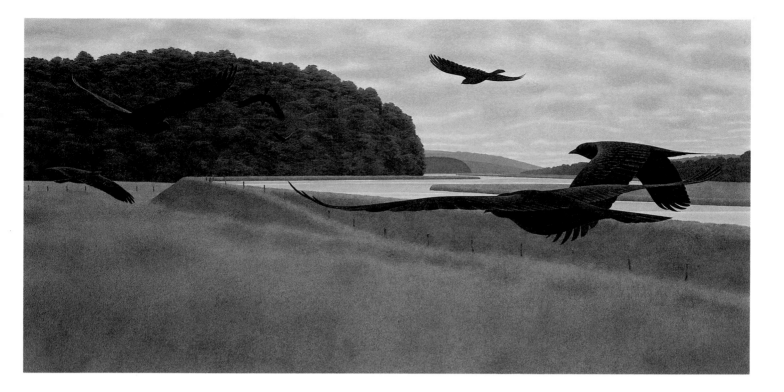

Seven Crows (1980)
Acrylic on particle board
60.0 × 120.0 cm
Private collection, Toronto
Photograph courtesy of Mira Godard Gallery, Toronto

Graham Coughtry

b. 1931, St. Lambert, Quebec

For me this represents the summation (for the present) of a long-standing obsession with the reclining female figure and with this subject's many incarnations in the history of art.

I had a large, square canvas that had been lying about my studio for some time and on which I had intended to paint an extrapolation of Ingres' *Turkish Bath*. However, in the rush to do one more painting for an upcoming exhibition (at the Isaacs Gallery in February, 1983) I hauled it out and decided to try to embody all of Ingres' ladies in one figure. To this end I first made studies using four models, whose skin tones ranged from African purple-black through oriental gold to Circassian ivory-white. I then attempted to coalesce the different qualities of each into a single figure in a real although simple space, emphasizing the grid rather than the volume of the space. It is interesting to compare this picture with a much earlier work, the *Corner Figure* of 1960, where the figure has a withdrawn quality as compared to the flaunting openness of the *Odalisque*. In both cases, however, the intent was to create a real presence through the wonders of oil paint. I hope that this painting fulfils a criterion I once read regarding the idea of *Odalisque*—"she eludes the imagination's hot embrace."

Toronto, Ontario

Odalisque (1983)
Oil on canvas
213.4 × 213.4 cm
The Isaacs Gallery, Toronto
Photograph courtesy of Tom Moore, Toronto

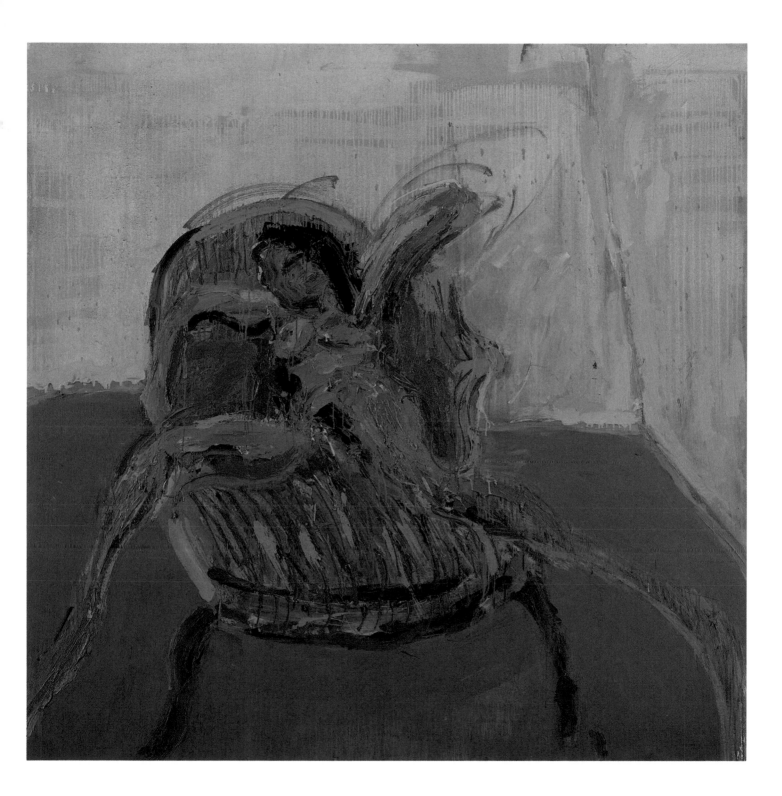

David Craven

b. 1946, London, Ontario

When I was first starting out in art, around 1974, I did a painting I called *Golondria*. I'm notorious for having a bad memory but I remember it and for me it's sort of a feat to remember a painting from more than ten years ago.

This was before my first one-man show at Jared Sable's gallery in Toronto. In preparation for the show I had gone through a difficult time with certain paintings. I remember having reached a plateau where I was becoming too finicky in terms of trying to find relational values within the paintings. And so, after a good deal of frustration, this one painting which was somehow the most direct came out. It was like a gush of hysteria. And it was one of the simplest. I'd been getting very confined with problems about the edge, with the framing, and this was a painting that basically came flat out, in a big sprawl of paint. It was a relief to me and after that other paintings came easier.

I remember Jared Sable coming down to the studio to choose work for the show. I was looking forward to Jared just flipping out over this painting. I was so self-assured.

Finally I put this painting on the wall and he said, "Oh no, that's definitely not good enough." I couldn't believe it! I said, "What are you talking about? This is a terrific painting!" We had a huge disagreement. So he didn't want it in the show, but he looked at it over the next month and he finally said, "Do you know I was completely wrong about that painting? I'd like to buy it." To this day, that painting holds down the main wall in Jared's living room, a place of honour in his house. I think it was the first painting he bought from me.

A lot of my paintings are scattered in various people's places and I never get to see them anymore. But this painting, because of my friendship with Jared, I get to see this one quite often. It still holds up for me. I remember it because it's beautifully situated in his living room, next to a small Donald Judd.

New York, N.Y., United States

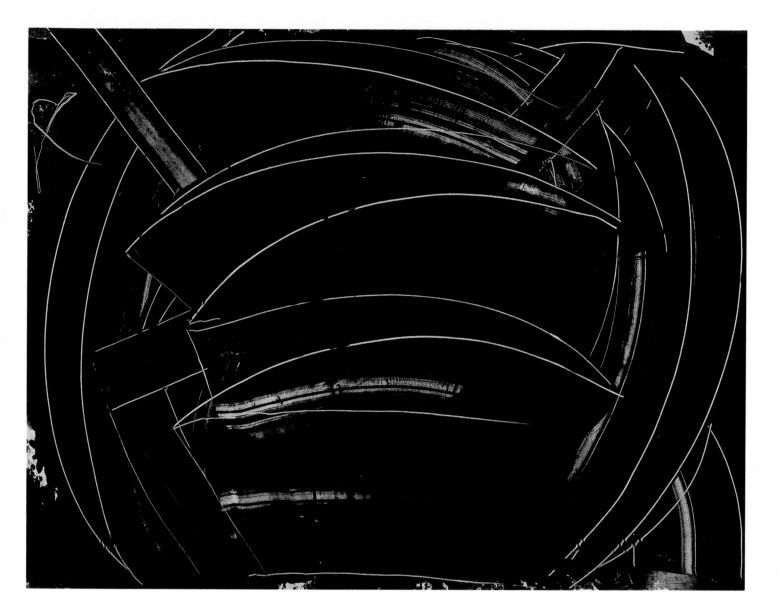

Golondria (1976)
Acrylic on canvas
213.4 × 274.3 cm
Nancy Hushion and Jared Sable, Toronto
Photograph courtesy of Tom Moore, Toronto

Greg Curnoe

b. 1936, London, Ontario

Genuine is one of a long series of portraits of my wife Sheila. The title reflects, to some extent, my interest in German films of the 1920s. *Genuine* is the name of a film from that period directed by Robert Wiene.

My recent pastels, and this one in particular, are a breakthrough for me. There is a type of portraiture which I have managed to do (in some of my watercolours and pastels of my children as well) where I have been able to get at something of the personality of the person I'm drawing. Sheila has a very complex personality, and people change, too, at different times of their lives. This is a very significant and changeable time for her and I've got this in the pastel. It's a real portrait that includes the whole body as well as the face.

With pastel the colour is pure because there is little medium in it to interfere with the pigment. An opaque complimentary can be put on top of another without greying the colours. A bright green pastel can be stroked over a bright orange and it will stay green on the orange, so very strong contrasts are possible.

This work is life size, done from life, with measurements taken from the subject.

London, Ontario

Genuine (April 1, 1985 – September 5, 1986)
Pastel on paper
176.0 × 87.0 cm
The artist, London
Photograph courtesy of Design Associates, Hyde Park

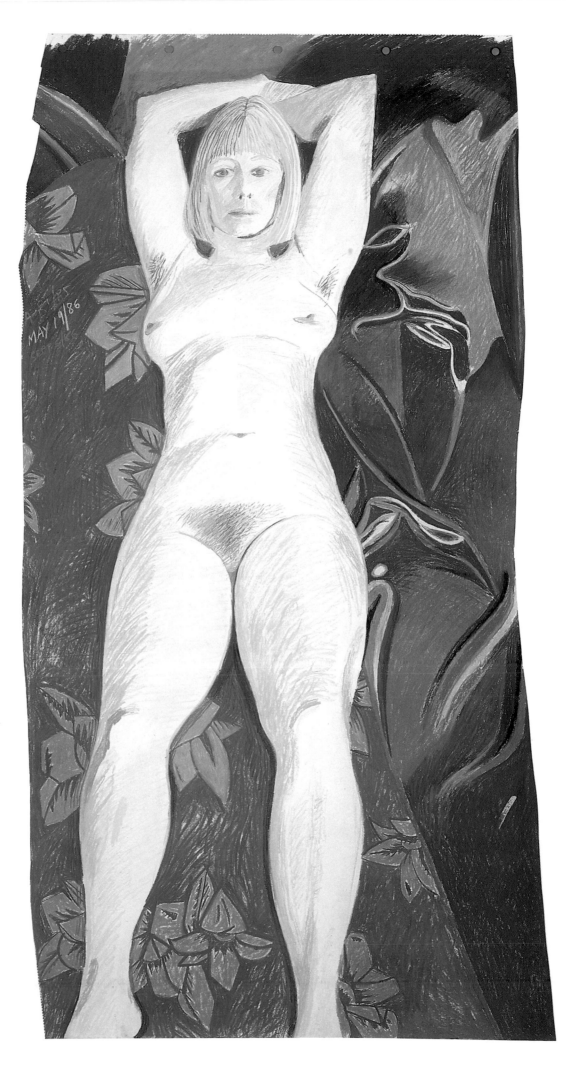

Ken Danby

b. 1940, Sault Ste. Marie, Ontario

The symmetrical design was challenging, as was the
need to create a sensuous and luminous light. I was
intrigued by the fact that the work combines both a
confrontational thrust with a peaceful calm.

Guelph, Ontario

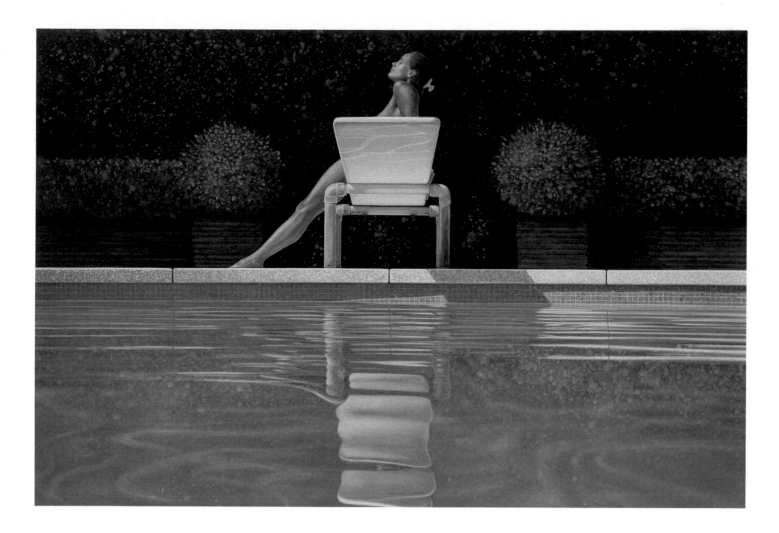

Acapulco (1985)
Egg tempera on panel
61.0 × 91.4 cm
Private collection, Toronto
Photograph courtesy of Gallery Moos Limited, Toronto

René Derouin

b. 1936, Montreal, Quebec

If, a few years ago, someone had told me that one day I would execute woodcuts of these dimensions, I would not have believed it. I had already, in the 1960s, realized large-format paintings but with these prints I had quite a different set of problems.

After twenty years of printmaking, one gets into the habit of creating a certain space and this space was becoming more and more limiting to me. In 1976–77, I made some woodcuts measuring 46 × 61 cm. This format requires a lot of a printmaker and imposed upon me a type of composition: landscapes. However, after each of these works, I found myself dissatisfied with the imposed limits. That is why, in 1977, I made the triptych *Suite Baskatong* which helped me "decompartmentalize" printmaking. My wish was to break through the frames of printmaking. My travels through the Northern Quebec territories modified my perception of space—what had appeared to me to be one sole image became a series of images side by side. I then adopted modular printmaking.

In the case of my *Suite Nordique*, I drew the main outlines of the composition following a helicopter view of the territory. Then, I engraved the plate flat on the ground so that I could recreate what I had seen from the air. Not long after, I was thinking of realizing a print that would develop this idea further. The concept of a geographical map that one folds and unfolds fascinated me; each part of the territory has its relative place, but as we unfold the map each one adds on to the other, forming a global view.

The murals *Nouveau Quebec* and *Taiga*, with their stylized forms of the northern peat bogs, refer in part to the northern territory. These murals also reveal my past and my academic formation. In 1956–57, I studied painting and murals in Mexico and was enthralled by Pre-Columbian art. Later I travelled throughout the continent and I also studied the Inuit and Toltec Art. I now realize that, though making a mural of New Quebec, I was synthesizing my influences. *Nouveau Quebec* could have been entitled "From North to South."

Nouveau Quebec required such a great deal of reflection and time that it modified my perception of the landscape. It is as if I had assimilated and coded certain forms to acquire an alphabet and started discovering a language. Colour completed this mutation. In fact, if I hadn't been fascinated by colour, I think I would not have finished the mural, which consists of twenty-one modules, each measuring 76 × 102 cm. I consider each module to be independent, separable from the others, since each was individually treated according to the given space. I had to engrave each of the twenty-one plates four times, for the four colours of impression. The colour motivated me during the realization of each plate. I discovered the vastness of the research open to me. This was a mutation in my printmaking work where, until then, the black-and-white drawing was dominant in spite of a few colours in the outlines.

The engraved plate is for me an autonomous piece; I could have exhibited solely the plate as a bas relief. I compare this to a wood sculptor who works with reliefs, creating shadows and light without any other colour than that stemming from the matter itself. The engraved plate is like a gigantic eroded territory; the furrows that I make reproduce time and the multiple transformations of the earth's crust. Before doing this, I try to absorb the laws of geological movement and transformation. I think these laws are the same for the infinitely small and the infinitely big. *Nouveau Quebec* refers to the northern territory but could also be an enlarged microscopic view of the human brain or a telescopic view of the planet Jupiter. Having realized this, I do not stop at details. I do the gestures and everything falls into place.

I am now working on applying my graphic designs to architecture.

Val David, Quebec

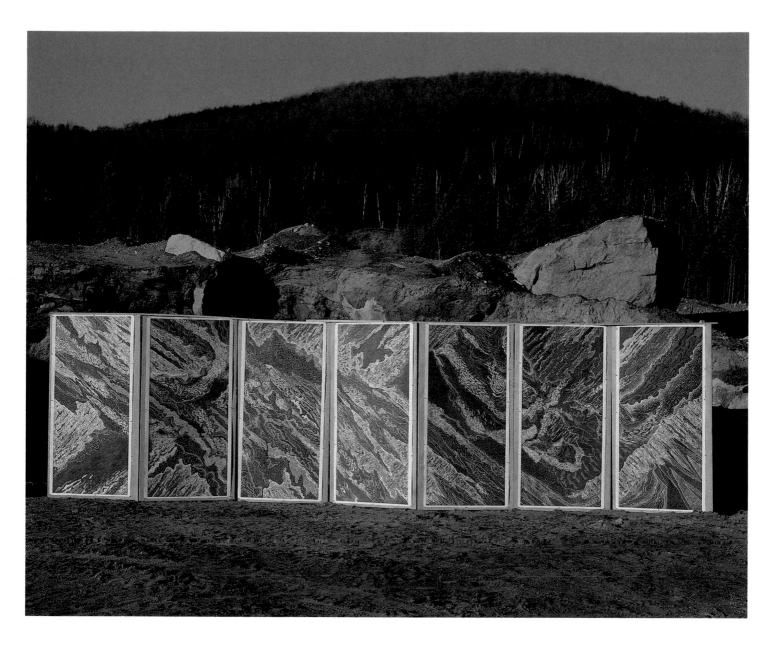

Nouveau Quebec (1979–80)
Woodcut
2.28 × 7.07 m
Musée du Québec, Quebec
Photograph courtesy of Yvan Boulerice, Montreal

Lynn Donoghue

b. 1953, Red Lake, Ontario

When choosing a favourite work a portrait painter finds that the issues of painting are occasionally obscured by the personality of the sitter. In choosing *Portrait of Goldie* over other works with which I am equally happy, I decided upon a work which was a simple portrait for a private situation as opposed to a major museum piece. This portrait is one of the closest to the tradition of "society" painting in my work and I approached it in that light.

I asked the sitter, a Toronto art dealer, to dress for the occasion and, if possible, to wear jewellery. She gave me the choice of costuming; I went for the John Singer Sargent draperies and flourishes. The sittings were in February, and the sun shone unusually throughout.

Because I had known Goldie for several years in a professional way, I did not have to go through a getting-to-know stage and it was easy to go straight for "the goods" of the picture. Within the costuming of "society," which for me is like playing dress-up, I was able to walk around ideas about the function of portraiture. I feel my interest in paintings intended to go into living situations has become stronger since I painted Goldie. For what I produce I want to see a context outside of the public situation. This naturally leads to a greater interest in works which are commissioned—a more traditional view of installation-oriented art.

The painting of Goldie reflects a toughness of approach to the viewer that is in both the sitter and the artist—and a sense of humour necessary for survival.

Toronto, Ontario

Portrait of Goldie (1983)
Oil on canvas
213.4 × 152.4 cm
Harold Konopny, Toronto
Photograph courtesy of Tom Moore, Toronto

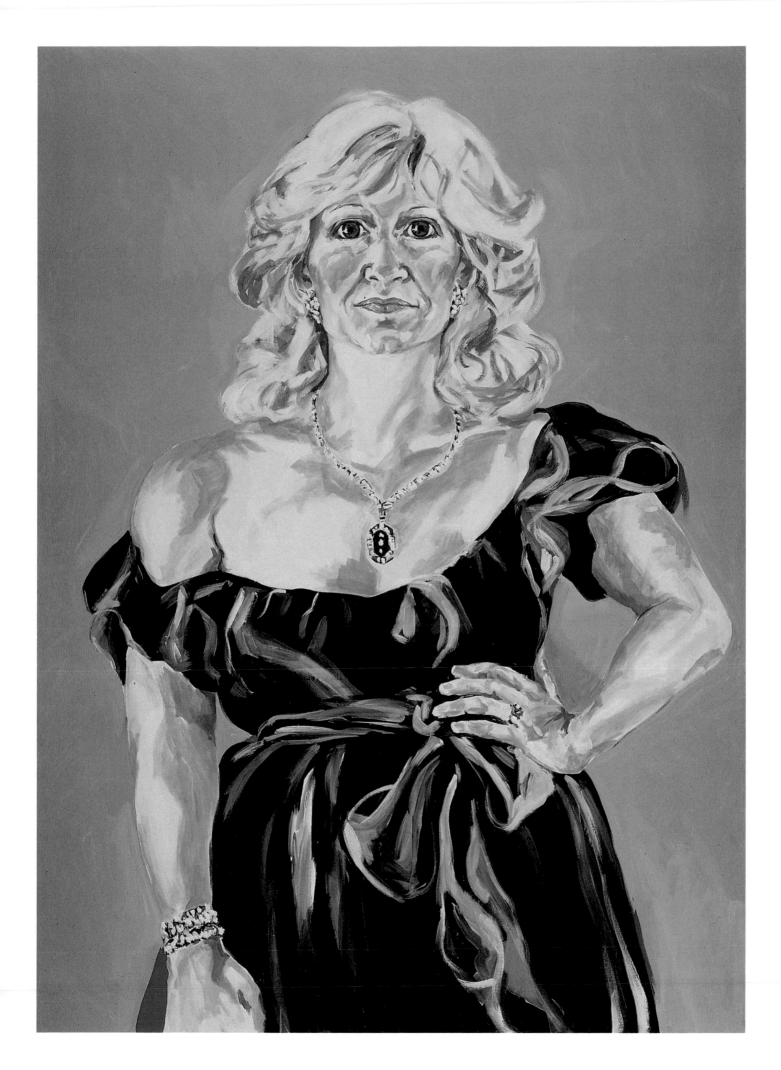

Alma Duncan

b. 1917, Paris, Ontario

As I haven't lived on this lovely property very long (I moved to Cumberland late in 1982) there are many surprises here. The seasons change and every day is different, especially in the country. Some sights provide a shock. Walking down the long green corridor of the driveway one day, I was aware of this great vine, suddenly reddened by the autumn weather, clinging to the trunk and branches of an old willow tree, its garlands hanging in the mass of lush green growing things reaching for the light on that soft September day. It seemed something out of time; yet I was part of it.

That is the way it is when you come upon an image that arouses strong feelings best described as absolute love. It is something you must record. And the work will live if you sustain much of that feeling while making it. I enjoy the sense of growth in the flow of forms and the determination of the red vine.

It is difficult to judge one's own work. Over a period, pictures appear differently when you review them. A work one thought of destroying seems, years later, to have some delightful qualities—or an earlier work you thought a treasure now seems without merit. Even so, I think *The Red Vine* will survive.

Cumberland, Ontario

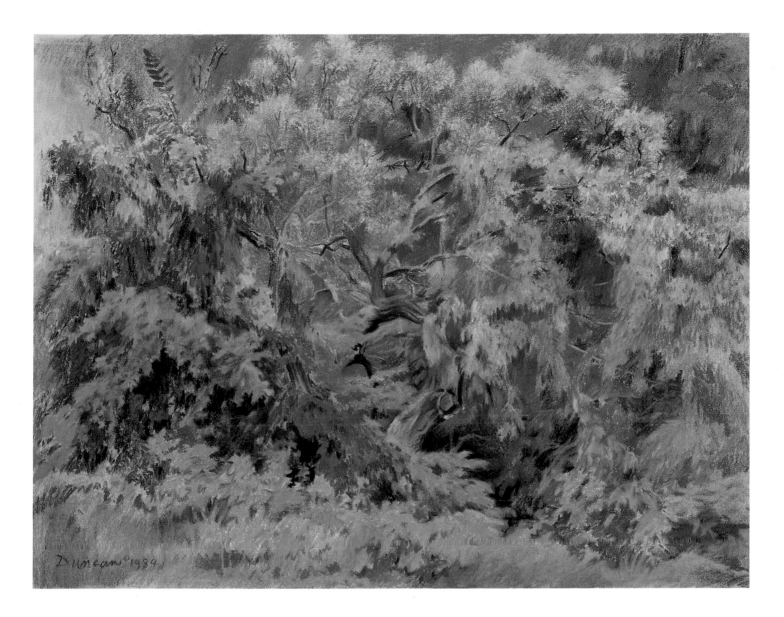

The Red Vine (1984)
Pastel on paper
50.0 × 65.0 cm
The artist, Cumberland
Photograph courtesy of the artist, Cumberland

Kosso Eloul

b. 1920, Mourom, Russia

I learned a long time ago how to integrate sculpture into its surroundings. It's like music: the acoustics of the hall dictate what you can do and how you go about your instrumentation and even what sort of instruments you choose. I've always been allowed to do the placing as a part of the design of the sculpture, part of the sculptor's thought. I simply become my own viewer. I stop being the guy who bellyached over it at home, thought about it, imagined it, arrived at the concept, and made it perfect in the basement (that's where I work). I bring the work outside—to the site—then I say, "Something is missing. It doesn't quite click. The effect is not right." In the basement I have no interruptions, no interferences. When I go outside, the whole world is there. It's a sidewalk situation with people and cars and everything else.

One of the best works I've ever done is in Ontario Place, *Passages*. It was a commission to celebrate Ontario's Bicentennial. I thought, "How the hell do you celebrate it?" Then I said, "It has to be something to do with the future. The past took care of itself." So it starts very solid, quiet, nothing different from any other two columns holding up a building or an edifice or anything else. Whatever happens is because of the third block and that's how I went at it.

I made about twelve models. As soon as I'd make the second one I'd say, "Wait a minute. Wait a minute. Here's a third one." And then I'd say, "The first one has something in it. The third one has something in it. Here comes the fourth one with something," and it goes, and it goes, and it goes. Then comes the process of elimination: "Which one deserves to be done and which is just a study? A search, a research?"

The piece is not alone. It stands on a big slope from Ontario Place going down to the parking lots right near the lake but there is a passage underneath lined with polished granite, black, Quebec Beebe granite. It's a famous granite; it's grey, and it seems to invite you to pass through it. Denoting passage of time. At the same time, it contains within itself a memory of 1984: a time capsule of our time. It is to be opened up in 2084 on Ontario's Tricentennial Celebration, when all the "treasures" hidden in it will be displayed as expression of our time and age.

Toronto, Ontario

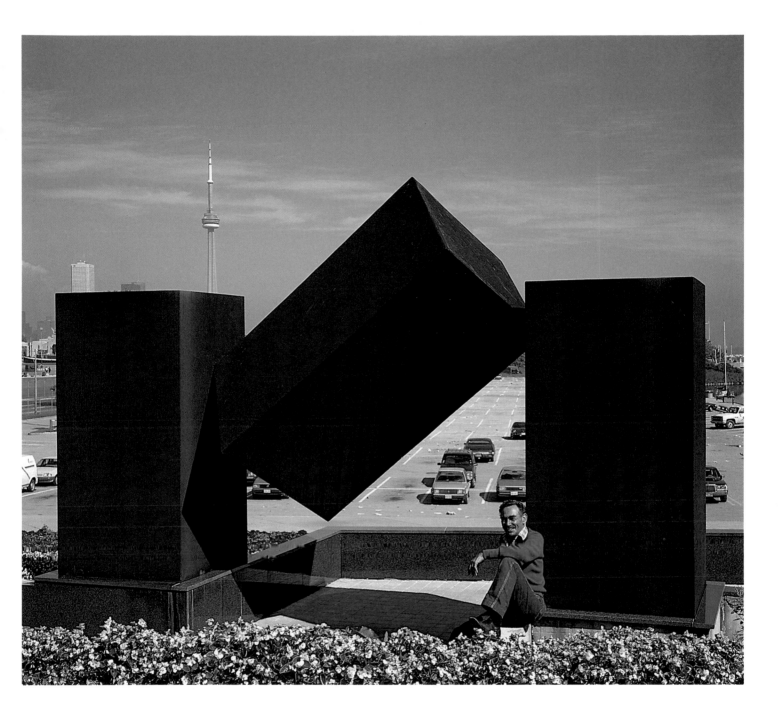

Passages (1984)
Ontario Bicentennial Sculpture
Corten steel (Stelcoloy)
40.6 × 40.6 × 12.7 m
Ontario Place, Toronto
Photograph courtesy of Tom Moore, Toronto

Evergon

b. 1946, Niagara Falls, Ontario

This was the last image made on the first shoot with the 1 m × 2 m Polaroid camera which is housed in the Boston Museum of Fine Arts. It was the culmination of several months of visual research and photographic sketches that I had been working on in the summer of 1984 in Argentina. It is the first piece in the ongoing *Works by Celluloso Evergonni*, works that include re-enactments of, or extensions for, existing themes or pieces by artists who lived in the Classical, Renaissance, or Post-Mannerist periods. The cloned look is Cara-vaggio's. The model was one of the three Polaroid techni-cians assigned to the shoots, extending further Cara-vaggio's use of working men and women in his pieces, as opposed to the comic or superhuman beings of the late Classics and High Renaissance. Caravaggio was one of the first to paint himself and the young men of his day with the sentimentalism and trappings of the previous Mannerists' coquettes.

Prior to working on this camera, I had been doing colour Xerox prints, SX-70 Polaroid prints, and 20 × 25 cm and 50 × 60 cm colour Polaroid prints. I often inter-locked the SX-70s into elongated vertical images. These, as well as the Xerox prints, have a similar format to the giant Polaroid prints. All the above processes are final-ized in less than ninety seconds—instant image-making with instant product and instant feedback. The sponta-neity of the working situation encourages the whole crew (technicians, designers, costumers, and models) to have input into the finalized work.

This camera is unique. It is primarily used to repro-duce two-dimensional paintings and tapestries. The camera is designed on the principle of the Camera Obscura and is basically a large room with a lens in the front wall and a film-holding vacuum board on the back wall. Two technicians work inside this room-box to process the film. Since camera and lens cannot move, the stage (76.2 cm deep with the props) and models are placed on a hydraulic lift and then raised into position and brought into focus on a scale of one to one.

The frontal plane of the stage is defined by a transpar-ent surface of plexiglass. The interior framing device is applied to this surface, as well as any painting, drawing, or photo collage work. In *The Caravaggio* you will notice an example of this in the streak of red paint in the lower half of the image and in the white rectangular frame. The plexiglass also serves another aesthetic purpose. Not until the use of the camera in the twentieth century does one see out-of-focus images. This lens has only a one-inch depth of focus, so the plexiglass confines this fron-tal plane to the model and physically keeps him from coming into a twentieth-century aesthetic.

The absence of negatives for these photographs makes each image unique. This, along with their grand scale, makes these works as valued and collectable as paintings and sculpture, allowing them easier access to museums and galleries.

Ottawa, Ontario

The Caravaggio (1984)
Colour Polaroid print
2.0 × 1.0 m
Canadian Museum of Contemporary Photography, Ottawa
Photograph courtesy of the artist, Ottawa

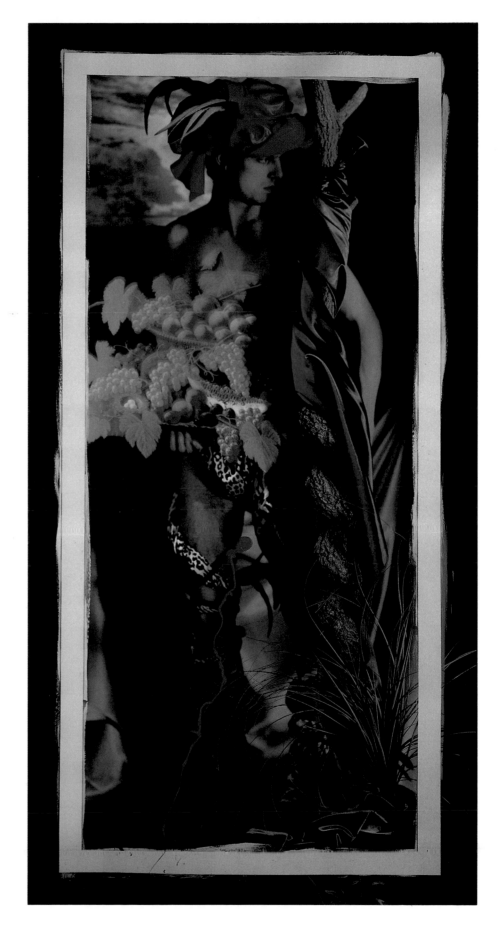

Paterson Ewen

b. 1925, Montreal, Quebec

This is the only self-portrait I've done in the approximately forty years I've been an artist. Although a painting normally takes me three weeks, I took four months on this work because of the psychological barriers. I felt as though I were a student artist! I started with the head, then tried to fit on the body. Then I realized that the way to handle the work was to attack it in the same way I would a landscape. I didn't want an exact likeness but the psychological feeling of myself. I look rough, and angry, menacing, but the colours are beautiful. I used ochre, gold, and a dark shirt and tie and a red oxide floor. There's some stormy weather in behind me, so there's a contrast.

This is probably the most difficult work I've done. It's strong. It looks realistic from a distance, and up close you can see the router and chisels at work, as you can so often in my work.

London, Ontario

Self-Portrait (1986)
Acrylic on gouged plywood
243.8 × 121.9 cm
National Gallery of Canada, Ottawa
Photograph courtesy of the Carmen Lamanna Gallery, Toronto

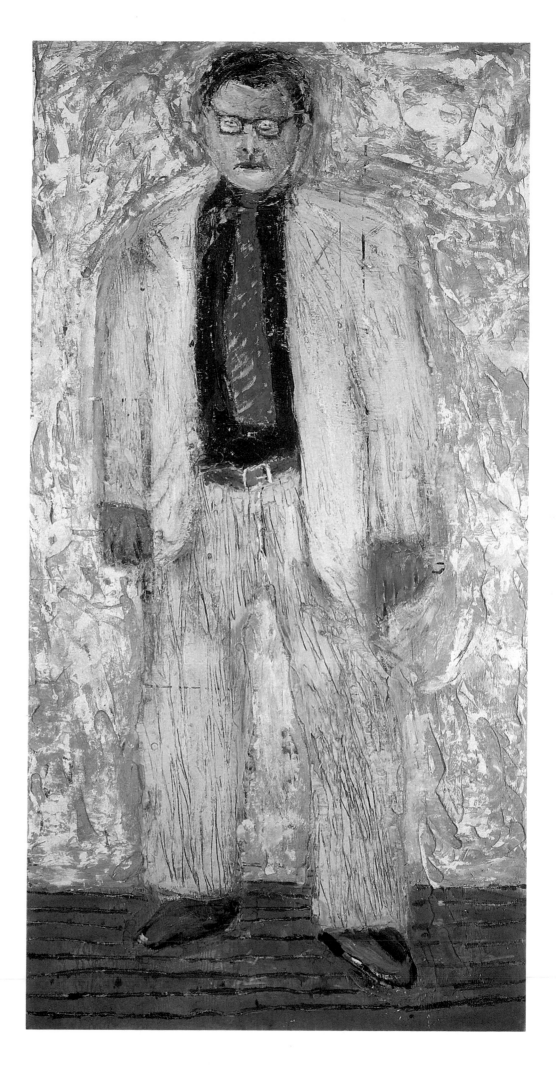

Ivan Eyre

b. 1935, Winnipeg, Manitoba

The Gold Box is as satisfying a painting as any I have painted in the past few years. It brings together, in a new way, elements from other works that have appealed to me.

In *The Gold Box* there are, perhaps, several "realities." It has three kinds of landscape notions. The first is the one against which the foreground objects are set; it has the mood of the grey paintings I did in 1968 and 1969. The second is a leafy autumn view painted on an open box in the front space; this connects to many landscape works I have done since 1972. A third treatment is embodied in the soft and linear form of the muted grass-covered left foreground, reminiscent of paintings like *Wild Oats* (1964) or *Prairial* (1966).

Probing another path are the two costumed figures on the right, based on self-portraits from the past few years—chalk and charcoal drawings in which I wrapped myself in various guises. At mid-point on the left side, another form variation is a large group of figures that connects to a painting like *Tullymet Plain* (1966) and other early paintings in which the human form dominated. The ceramic coffee cup in front makes a personal connection to my 1981–82 stay in New York, where I purchased it in a SoHo pottery studio. Also included in the painting is a partial view of the paint-spattered chair that I have had in my studio since the early sixties.

The upper third of the work is dominated by a man-made landscape which relates to the life of big cities and, in some ways, to *Storm* (1982), *Birdmen* (1980), and *Factory* (1977), among others.

The concept of a painting-within-a-painting has interested me from the beginning and is a feature of several of my works. The question it poses about meaning and the role of art itself is as important for me as any meanings inferred.

Winnipeg, Manitoba

The Gold Box (1985)
Acrylic on canvas
189.3 × 173.3 cm
The artist, Winnipeg
Photograph courtesy of Ernest Mayer,
Winnipeg Art Gallery, Winnipeg

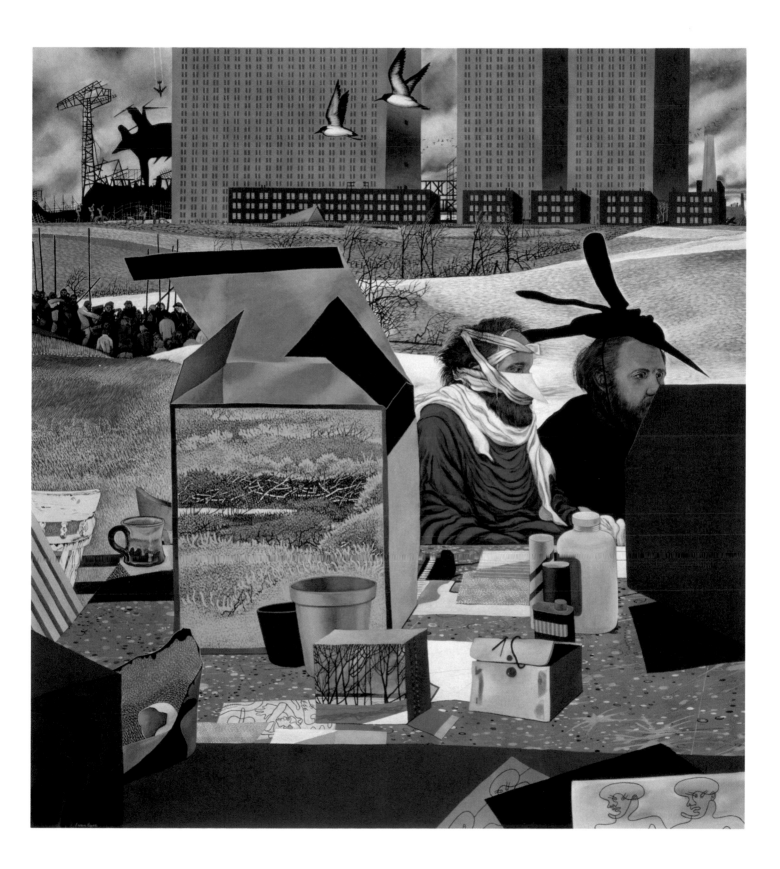

Joe Fafard

b. 1942, Ste. Marthe, Saskatchewan

For me the most important sculpture I ever did was the very first one. In September 1964, in order to fulfil curriculum requirements in my third year of fine arts at the University of Manitoba, I enrolled in a sculpture class at the Winnipeg School of Art. The first classes were innocent enough. Two or three times, out of clay we built heads modelled after a sitter, more or less. We tore these heads apart at the end of the afternoon and stored the pieces—ears, noses, lips—in the claybin, then revived them the next day. I don't count those as my first sculpture. Things got exciting when the wise young teacher, John Daniel of Port Arthur, Texas, announced that the students were free to make a sculpture the next week. It was electrifying! Right away on my evening walk home I knew what I would do and how I would do it: I would make a man, a small man sitting on a small chair.

I scoured the used furniture stores in Winnipeg that sunny Saturday for a chair. For a few dollars I found something. I also bought some plaster, made a few sketches on paper napkins in restaurants, and kept the image warm inside me. Monday I set to work at the first opportunity. I was transported. I felt I had discovered magic. When the man from Port Arthur saw just how well it was going, he came over to help.

The character I was creating was loosely based on my past reality, not on that magic moment, so naturally it had a bit of a hangdog look about it. Father John of Texas, on the other hand, felt that I should inculcate my figure with the fear of something—of God perhaps, as was the manner of the sculptural times. This could be achieved, he maintained, by turning the sculpture's head toward the cosmos. This small pleasure I afforded him. After all, I reasoned, he had set me free just last week, even if he had put his hand back on the rope just now.

I finished the sculpture and was delighted and proud. It was in my basement for the next two years. Yet that head—that head reproached me with its sideways turn and upward glance. I sometimes wonder if that's why I eventually shoved my first-born sculpture in the garbage bin.

Regina, Saskatchewan

Little Man on a Little Chair (1964)
Plaster and wood
91.4 cm high
Work destroyed
Photograph courtesy of the artist, Regina

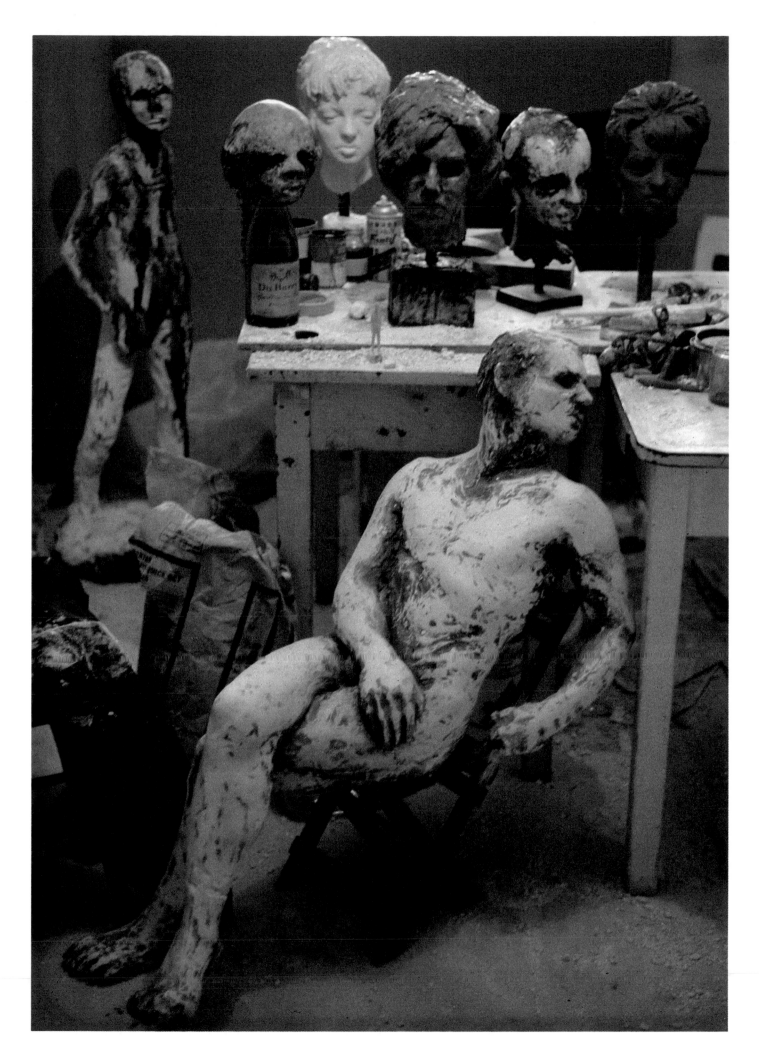

Gathie Falk

b. 1928, Alexander, Manitoba

To pick one's best work seems impossible. If the request had been to pick the most beautiful, the most joyful, the angriest, the one with most social content, the most depressing—that would be comparatively easy. The best is impossible. There are too many concerns to weigh against too many entirely different concerns. The problem is magnified when the body of work to be weighed encompasses painting, sculpture, and performance art.

For that reason, I have seized on one of my latest paintings, which is still in my studio, where I can study it. This is from a series, *Soft Chairs*, and is called *Soft Chair With Winged Dress*. Its strengths include a combining of opposites: the beautiful and the harsh. The dress is beautiful, the wings are enormous taffeta flounces. On the other hand, the attitude of its sitting empty, crumpled on the chair, looks unpleasant, pathetic at least. The softly decorated chair contrasts strangely with the strong red and hot pink of the walls behind. The careful modelling of the dress is set against a wall painted in a way not aimed at bringing out the modelling or structure of that wall, but apparently in an expressionistic slap-dash rendering of (flocked?) wallpaper.

Another way in which opposites are combined is the setting of thin transparent washes of paint beside thick areas of colour. This is a method of painting I have been pursuing with uneven success for the past few years. I think it works here. I think it expresses best my own nature and way of seeing things.

Where did these images come from? The chair and the dress are things I have seen throughout the years in different households. The lily is a different matter. I had a desire, about ten years ago, to paint a large closet with medieval images—lots of dark green foliage, animals, flowers, and supernatural happenings. The desire to paint this closet and make it into a place of meditation has grown weak through the years, but once in a while something from those walls enters my work. The potted lily is such a transfer. It was unpremeditated; one of those things that happen while you are painting.

To choose *Soft Chair With Winged Dress* as the best thing out of twenty-five years is entirely arbitrary; in a few weeks or months I could make another, perhaps older, choice. But all the same, I think this painting will be worth looking at for a long time.

Vancouver, British Columbia

Soft Chair With Winged Dress (1986)
Oil on canvas
121.9 × 106.7 cm
Private collection, Toronto
Photograph courtesy of Robert Keziere, Vancouver

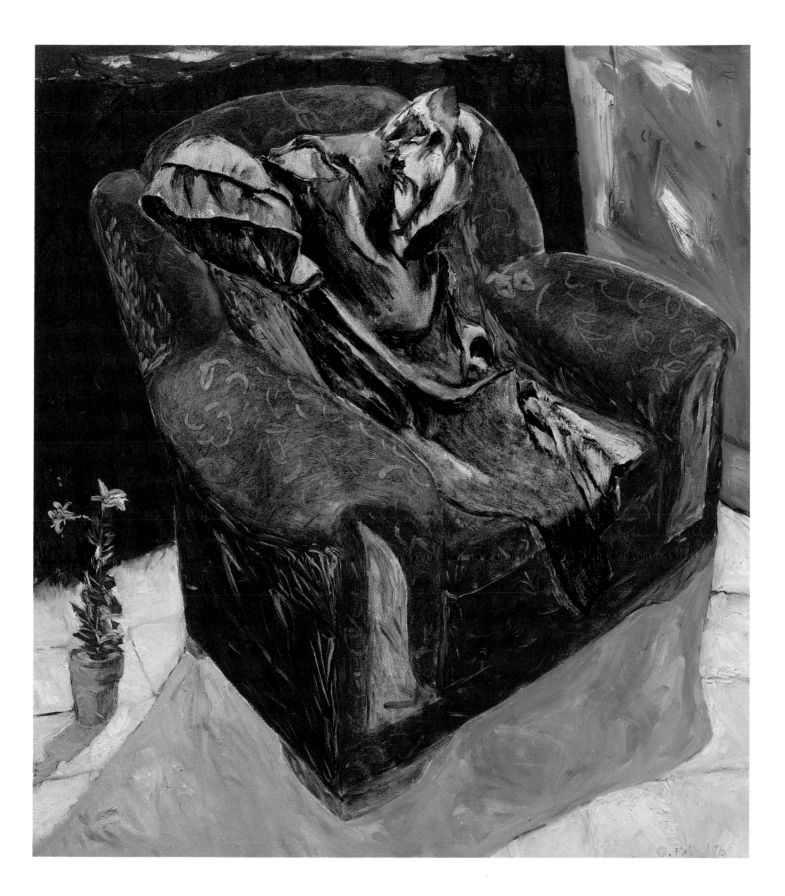

André Fauteux

b. 1946, Dunnville, Ontario

I am an abstract sculptor. I work intuitively and I decide
the sculpture is finished when it satisfies me. This
feeling of satisfaction takes place when the sculpture has
a presence that separates it from other objects in the
world and is also physically absorbing. This particular
sculpture, *Coming Apart*, interests me because I become
engaged and absorbed with the way the two lozenge
shapes separate from each other.

Toronto, Ontario

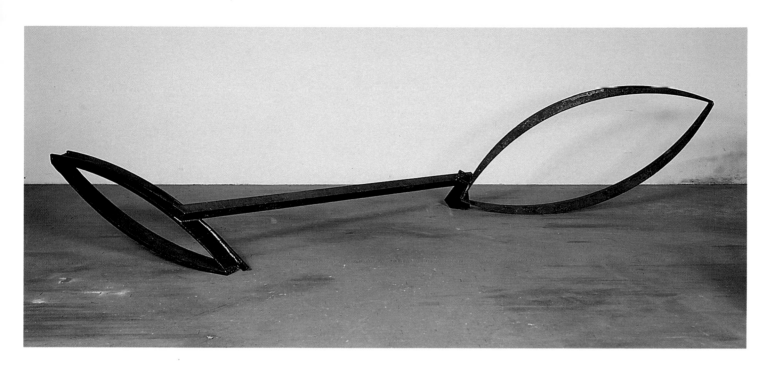

Coming Apart (1985–86)
Welded steel
1.02 × 2.02 × 4.99 m
The artist, Toronto
Photograph courtesy of Tom Moore, Toronto

Tom Forrestall

b. 1936, Annapolis Valley, Nova Scotia

It would not be fair to say that the egg tempera *The End of a Winter's Day* is my most successful work, or my favourite, or the most popular; but I can say it is one of the very few paintings I've done over the years of which I expected a great deal. After all, expectations are a great deal of what art and creation are all about. How much my expectations were satisfied in this painting is hard for me to say: as with all of my efforts the painting was a disappointment on completion. It never lived up to the ideal I had conceived and saw in my mind's eye.

Humans, animals doing something in a familiar landscape, these are the ingredients which appeal to me and the painting shaped itself to contain the idea. *The End of a Winter's Day* is a man in his orchard pruning his trees and his dog nagging him to head for home.

How can one finish a painting one is not satisfied with, a painting that is a disappointment? The answer is a simple one and an honest one. As in all my works I've done my best, made my greatest effort. No one can ask more of one.

Dartmouth, Nova Scotia

The End of a Winter's Day (1979)
Egg tempera on paper
86.4 × 50.8 cm
Nova Scotia Department of Culture, Recreation and Fitness
Photograph courtesy of the artist, Dartmouth

Charles Gagnon

b. 1934, Montreal, Quebec

In my childhood during the war there were no toys except for sturdy hand-me-downs, the comic books were black and white, and television, of course, did not exist. Radio was quite different from what it is today—I recall the daily suspense programs. What I'm saying is that all games had to be made up and stories and sounds had to be visualized. This probably became the foundation for all that was to follow in my work.

In New York, from 1955 to 1960, I began connecting what was in (not on) my mind with things that I could see and hear, from ancient art at the Met to experimental films, dance, and music. My paintings of that period related to walls and concrete marked with signs of time passing through space; floating hieroglyphs and numbers and systems waiting to be decoded.

In 1960 I returned to Montreal, where my studio had natural light. Gradually spaces opened up and colours changed. Nature replaced history. The calligraphy of signs became the structure of objects, not literal but abstracted in order to avoid overdefinition. Interpretation should always remain open. I am interested in the speculative. I must question and be questioned not only by the work in progress but also my own intentions towards it.

Increasingly the space "between things" became more important to me than the things themselves. These "volumes" seemed to be charged with undefinable potential. Looking at nature with the eyes, one sees objects and the space between these objects; one sees foreground, background, etc. The viewpoint is always frontal, the eyes being the axis, adjusting their focus, and the mind its attention, to this object or to that object but always from "here" to "there," the "here" being "I." If one could eliminate the "I" or self, or perhaps multiply the "selves," one could perhaps have a simultaneity of views and perhaps, then, perceive the "essence," the real matter.

During late 1962 or perhaps early 1963, I turned from material nature to conceptual nature. The work reproduced here, *The Sound*, is from that period. This work seems to contain the seeds for all that followed, and from time to time it has served as my conscience. I have forgotten the precise reasons for its title—perhaps it was just instinctive—but over time I have noted from various sources the following:

When perceiving, it is the eye that sees and recognizes, but when conceiving it is the mind that hears and reflects and that which is heard is the echo of things.

> Gerardo Reichel and Dolma Toff, "Amazonian Cosmos" from *The Desana Tribe; Amazon* (1971)

Sound seems to occupy all the room between us and their source.

> William James

Sound discloses a space which instead of consolidating the boundaries between within and without, obliterates them.

> Victor Zuckerkandl

> Montreal, Quebec

The Sound (1963)
Oil on canvas
101.6 × 91.4 cm
The artist, Montreal
Photograph courtesy of Pierre Charrier, Montreal

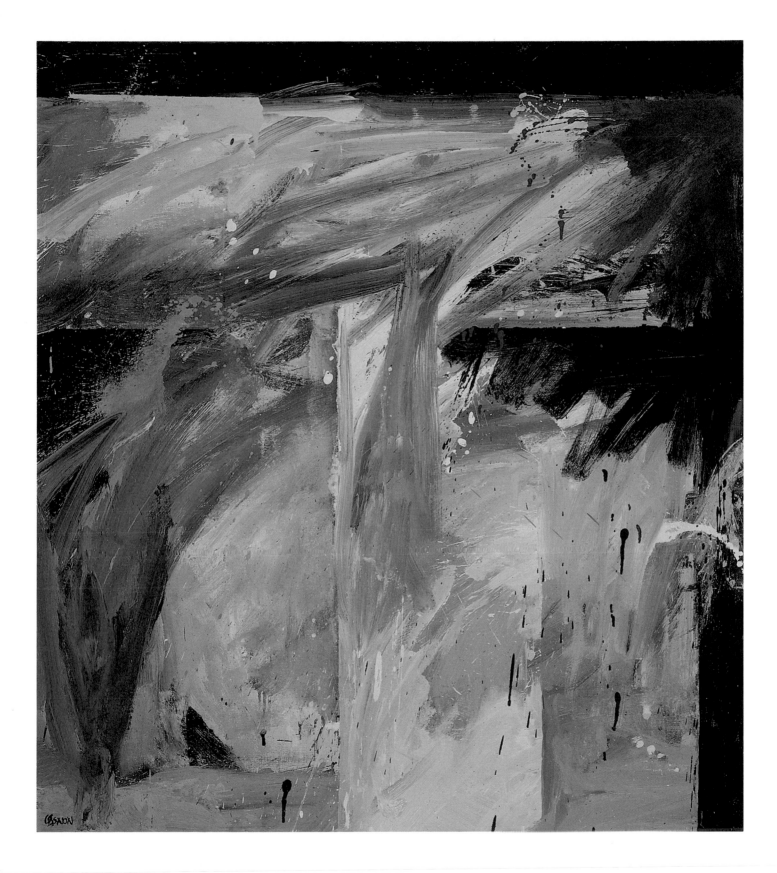

Yves Gaucher

b. 1934, Montreal, Quebec

As in *Jericho—1*, this particular painting is the witness of a precise moment in my artistic evolution. My paintings are not the visual outgrowth of an outside philosophy. Each painting is both the vehicle and the synthesized product of a private dialogue with the material—paint, canvas, subject matter, concepts, styles, aesthetic theories and principles. Thinking is done *in* the medium, and the thinking process is synthetically embedded in the painting.

It is that synthesized product that I hope viewers will explore, in the process becoming my creative accomplices. The work of art will then achieve its fulfilment through existential exchange between artist and spectator.

Montreal, Quebec

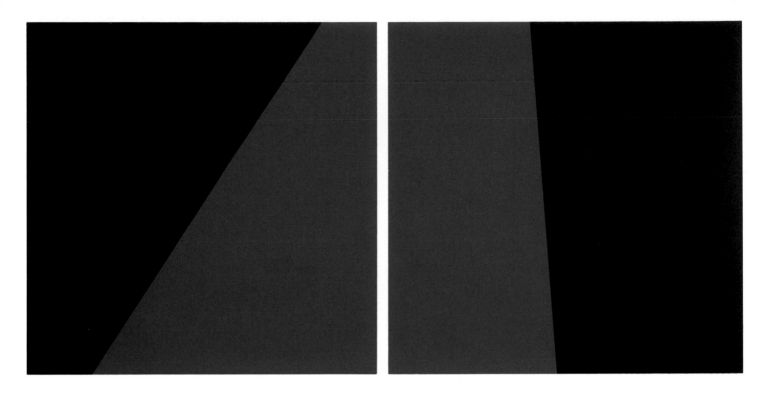

Jericho—2 (1978)
Diptych
Acrylic on canvas
Each panel 274.3 × 274.3 cm
The artist, Montreal
Photograph courtesy of Pierre Charrier,
Montreal

Betty Goodwin

b. 1923, Montreal, Quebec

My work proceeds in cycles. The energy from each cycle
leads to the next. I see my key works in terms of break-
throughs. This is one of the first of my swimmers. The
series includes *In Berlin*, *Triptych*, and *The Beginning of
the Fourth Part*.

Montreal, Quebec

Untitled No. 2, Swimmer Series (1982)
Oil and oil pencil on paper
294.0 × 324.0 cm
Montreal Museum of Fine Arts, Montreal
Photograph courtesy of Montreal Museum of Fine Arts,
Montreal

Tom Graff

b. 1945, San Francisco, California

Surgical Masque is a live presentation using people, images, sculptures, and words, all in a clinical setting. We all look like medical people. The setting is almost all white. I perform a surgical procedure on a turkey while the class of future surgeons looks on. They even interrupt, but nothing will stop my surgical instructions to the nurse, nor my implanting of certain objects into the turkey (a mass-produced, featherless, white-pink-white mound of flesh). Always visible on the two TV monitors are close-ups of the surgical table.

In addition to reciting, chanting, and singing texts I have collected in a book, we relate in a matter-of-fact way the story of a young Canadian, named Slautin, who helped make the first atom bomb and, a few weeks after Hiroshima, fried himself atomically because of his technique of handling the active particles with two screwdrivers.

The performance is juxtaposition upon juxtaposition. All the time we are very polite as performers, with each other and with the audience. The music ranges from Anglican chant (with words from secret notes to Truman regarding the suitability of Hiroshima or Nagasaki for experimenting with this new super-weapon) to Puccini, snippets from Stravinsky, Black Gospel, Schubert *lieder*, and rhythmic chants from my own musical mind on anthropological, aesthetic, and scientific texts. The chants are recited by the class of future surgeons. Loud, soft, fast, slow.

The pun on *masque* and *mask* is a kind of base reflection on the visceral aspects of the piece. We do wear surgical masks in the piece. And it is a masque, in a quiet way, within the tradition.

The piece has some wit, as well as some horrible moments, such as the final stab of the turkey before it is placed on a rotating barbecue, and some tender times, such as the tableau moments when action stops. Like Kabuki.

This is my most important work so far because it addresses some of the large concerns of humankind today while not preaching. It becomes powerful, at least for me, because the bomb and all the militaristic power posturing that it implies are inherent in the surgery, the very act of violating an animal body—yet we accept it. We all participate somehow. That scares me and excites me as well. It takes me beyond my own art.

Vancouver, British Columbia

Surgical Masque: Not the Manhattan Project
Performance and installation commissioned by the Music Gallery, Toronto
Performed in Vancouver at the Western Front (1½ hours, part of *Tom's Diary*, a 4-hour installation performance) and at the Music Gallery, Toronto
Photographs courtesy of Chick Rice, Vancouver

K.M. (Kate) Graham

b. 1913, Hamilton, Ontario

Although ideas for my paintings have come from a great variety of experiences, my numerous trips to the eastern Arctic have been a never-ending inspiration for my work. In the Arctic, wind and ice have stripped the landscape to its essential elements. That, plus the overwhelming sense of open space and unexpected colours, has had a strong visual impact.

Arctic Gorge resulted from an experience I had while walking on the tundra on Baffin Island near Cape Dorset in 1975. Suddenly I came upon a stunning cleft in the tundra, unlike anything I had seen before in this part of the Arctic. I made two or three quick pencil notes but I had a feeling that some day I would want to base a painting on this experience. I should explain that I never carry a camera; I don't want to lose the impact on my own visual impressions by fiddling with a gadget.

The impact of this experience has stayed with me for over ten years but only recently have I been exploring the possibility of putting it down in various forms. I find that, removed from the experience by such a time span, I am able to select the essential elements and rearrange them in my own way. My landscapes are never literal.

Recreating a landscape on a vertical canvas, as with this painting, poses an interesting problem. From the shapes and structures I have observed in nature, I invent or re-invent a composition. Sometimes it may be almost totally abstract, as in the "Field and Moor" group of paintings of 1976 or the "Perennial Border" group of 1981. Other times, the forms may be recognizable, as with *Arctic Gorge*. However, in all of the works I take great liberty with the colour, using it arbitrarily for the most part—anything to make the painting lively as well as enhancing it as a work of art.

Drawing has always given me a great deal of pleasure. In *Arctic Gorge* I particularly enjoyed putting down the full-arm drawing of the rocky side areas. It was done spontaneously and developed as I worked. I like to attack the bare canvas directly in this way. It is always a challenge as there are very few adjustments that can be made later. The brightly coloured strokes are purely optical and intuitive. No colour is repeated. I like to keep the colours casual and slightly "messy," in keeping with the spontaneity of the full drawing.

The water was made lively and exciting by many layers of thin washes. The wave effects are deliberately playful, strong and painterly. The far shore presented different problems. Here I subdued the drawing and used mainly tints of colour. The effect is, I hope, one of mass.

I like to think that in this painting colour, drawing, and painterliness work together to move the eye over the surface in a lively manner. I deliberately avoid linear perspective, rather using colour to give the shifting, open-ended depth of ambiguous optical space as well as to provide colour treats for the eye.

Toronto, Ontario

Arctic Gorge (1986)
Acrylic on canvas
203.2 × 109.2 cm
Klonaridis Inc., Toronto
Photograph courtesy of Tom Moore, Toronto

Alexandra Haeseker

b. 1945, Breda, Holland

There is a magic about outdoor dog shows that's similar to a Fellini circus. The assemblage comes in the night, is there for a few days of colour, excitement, and unreality, and then is gone, off to be rebuilt somewhere else the next day.

The inspiration for my *Enclosure* paintings comes from observing the shelters erected by exhibitors for their canine competitors at summer dog shows. Temporary campsites form the sidelines at these events, and in themselves are a brilliant spectacle of closely packed paraphernalia. The interplay of colours and bright reflective surfaces almost overwhelms the animals held in protective security.

I have always investigated the isolated figure in my work; now the isolation is enforced by the aggressive overcrowding of the enclosure. The format of the canvas itself assumes part of this role, supporting the drapery in a theatrical manner, compressing the space to a shallow, stage-like setting. The dog as figure defines the claustrophobic area he occupies.

Enclosure: Private suggests a confrontation in which the viewer is potentially an intruder. At first glance everything is veiled: the cage, its inhabitant, the translucent tent corner in the foreground. The physical reality of the Doberman is interrupted by the grid of the pen; conversely, the dog and barrier unite as one to repel invaders. His presence gradually asserts itself.

Calgary, Alberta

Enclosure: Private (1985)
Acrylic on canvas
127.0 × 165.1 cm
Mira Godard Gallery, Toronto
Photograph courtesy of Jeff Nolte, Toronto

John Hall

b. 1943, Edmonton, Alberta

Cut, completed during a three-month residency at the
Leighton Artist Colony, in many ways summarizes the
issues central to my painting over the last twenty years.
At the same time, it's different, structurally at least,
from many of the pictures which predate it.

I have long been interested in expressing a world
view through the vehicle of still-life easel painting.
Essentially conservative, my paintings have always
tended to celebrate clarity, craft, traditional values in art,
order and simplification. At the same time they argue
against ambiguity, emotion, carelessness, and irresponsi-
bility. In their conservatism they strike me as being,
quite possibly, quintessentially Canadian. There is a
pioneer pragmatism reflected in my work that eschews
the opulence of more comfortable and sympathetic
climates.

In its imagery *Cut* points to the culture/nature
interface, subtly suggesting that we can only experience
nature through the clarifying filter of culture. In this
picture, art, as represented by a fairly aggressively
assembled pile of painting hardware, stands between the
viewer and the landscape, eclipsing virtually all of the
landscape. In the picture's close and dynamic cropping
the art objects symbolize the way art (culture) insists on
determining the ways in which we perceive ourselves
and our environment.

Calgary, Alberta

Cut (1986)
Acrylic on canvas
152.0 × 152.0 cm
Garth H. Drabinsky, Toronto
Photograph courtesy of Wynick/Tuck Gallery, Toronto;
John Dean, Calgary

Noel Harding

b. 1945, Ilford, England

The Blue Peter Series emerged through a desire to create monuments to the victims who survive within the accepted norms of society. My interest has been the failure of these innocents to survive their own psychology. Somehow there's an elegance and truth to such people. They, like victims of war, deserve to be honoured.

Blue Peter as a Bronze Water Fountain was the beginning of the Blue Peter Series. The figure, about to step into the water, wears a wrinkled suit. The bottom of his stepping-out leg dangles from fine wires; it wiggles (a small motor is used) over the surface of water. The image expresses a fear of the future. The character needs to be bronze to produce the effect of stability and duration; the tentative nature of the wiggling foot counterbalances the tradition of the bronze. I used the idea of a businessman risking himself.

My series of Blue Peters, now complete, also included *Blue Peter* (the character having stepped into water with real soiled clothes, real hair—implications of the derelict) and *Blue Peter Steps Out to Remember* (the character stepping out of water, a combination of steel and real clothes, jazzy dress but carrying his past).

Toronto, Ontario

Blue Peter as a Bronze Water Fountain (1986)
Bronze cast life-size figure, blue water, water pump, rubber pipe, electric motor, wire, copper tubing, gas flame, plexiglass, lead
243.8 × 182.9 cm
Commissioned by Sheffield City Polytechnic, Sheffield, England
The artist, Toronto
Photograph courtesy of the Ydessa Gallery, Toronto

Douglas Haynes

b. 1936, Regina, Saskatchewan

I give a title incorporating Banzo (a character from an old Japanese Zen story, *The Taste of Banzo's Sword*) to pictures that catch me off guard, lead to better pictures, and teach me how to be a better artist. They could also be called breakthrough pictures, although I am not completely comfortable with that term.

In January 1978, I painted a picture I thought was terrific, the high point of a series. I left it on the wall in my studio when I went to New York for a few days. There I saw a remarkable Matisse at the Knoedler Gallery, a 1928 still life—*Gladioli*. It was kind of zany—brushy and loose at the top and harder and more geometric at the bottom. The picture stayed with me and still does. When I returned to my studio my "terrific" picture looked pretty bland, so I promptly repainted it and found a far superior picture in its place.

In this instance, my own work taught me how to watch for that moment when a good picture can be made better. It reminded me to be constantly on guard for surprise lessons.

Edmonton, Alberta

Banzo's Last Stand (1978)
Acrylic on canvas
180.3 × 166.4 cm
Agnes Etherington Art Centre, Kingston
Photograph courtesy of the artist, Edmonton

J.C. Heywood

b. 1941, Toronto, Ontario

The idea of theme and variation is natural to a print-maker who spends a lot of time proofing, trying out, and comparing all the implications of images. I create my images tentatively, explore them in depth, compare the various visual ramifications, make decisions, and fix the sum of all this experience onto the plate. Then I begin all over again in a fluid state, using the plate as a starting point for further exploration of the image. (This ties in very nicely with a Buddhist philosophy of participating fully in life while standing outside, seeing it as a thing apart—reification.)

This four-part *Braque* etching and drypoint is based on a 1911 Cubist drypoint of Georges Braque. He was dissatisfied with his image and cut up the plate, hoping to find a composition within his composition, but apparently didn't like it and didn't publish it. It may have been the unresolved quality of his image that made it so interesting to take up as a theme, for variation. My other inspiration at the time was Bach's *French Suites*, brilliant examples of musical variations on a theme. Ideas of many different kinds fitted together nicely in this print because Cubism has so much to do with seeing things from multiple viewpoints at the same time—a notion very congenial to me. (And to the Canadian experience, I think.)

The plates were very interesting to make and I spent months preparing them. Cubism is such a combination of clear structure and confusing accretions. It moves back and forth between the real world and abstract formalism. So I felt free to amuse myself with different visual manners and technical approaches; to incorporate my approximations of the traditional etching "look" of techniques like hard ground, soft ground, crayon manner, drypoint, aquatint, engraving, foul bite, roulette, sugar lift, criblé, and so forth.

The printing of the Braque variations is quite complex and I had to go for a three-month apprenticeship to the Kätelhön etching shop in Germany to discover with their master printers what colour possibilities there were in the plates. We did variations within variations as new ideas arose out of existing ones. This work was an exciting adventure for me and an example of one of the thrills of printmaking—the way your ideas force you to develop new techniques and then the techniques themselves give rise again to new ideas.

Kingston, Ontario

Braque Variations (1985)
Four-plate etching and drypoint
105.0 × 300.0 cm (each plate 90.0 × 60.0 cm)
Toronto Dominion Bank Collection, Toronto
Photograph courtesy of the artist, Kingston

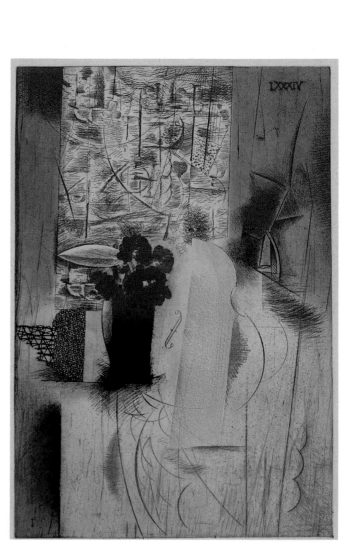

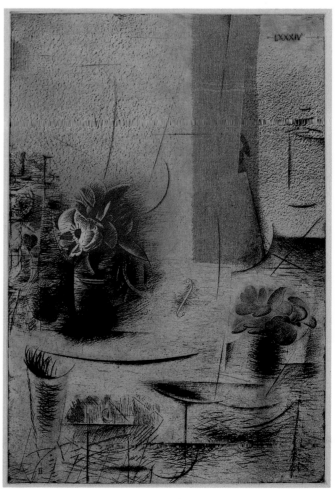

Gershon Iskowitz

b. 1921, Kielce, Poland

The painting is based on my experience of the Northern Lights on a trip to Churchill, Manitoba, in 1967. This work was a long time coming, but many other of my previous paintings were inspired by trips I made to the North. Yet, as with many artists, it is usually the most recently completed painting that is the most important to me. In this instance, however, the importance lies in this *series* of paintings. Here is the reason why: I had in mind for a long time to paint a polyptych where I could really create lots of space and depth in terms of the sky and flying shapes. I drew a lot of plans to develop the shapes of this polyptych and, by trial and error, evolved this shape.

I must caution the viewer: the entire painting lies flat on the wall! It is not three-dimensional. Now, take another moment and have another look, because each shape forming the polyptych is different, and yet the entire composition is harmonious. It seems to me that the seven-part shape of the canvas is something new, as nobody has ever done this before. I feel that such a painting as this, if seen in reality, translates really well what I wanted to say.

Toronto, Ontario

Northern Lights Septet #3 (1986)
Polyptych
Oil on canvas
241.3 × 408.9 cm
Gallery Moos Limited, Toronto
Photograph courtesy of Gallery Moos Limited, Toronto

Shelagh Keeley

b. 1954, Oakville, Ontario

In January 1984, I was asked to execute an installation in a room in the Embassy Hotel. I chose room no. 31 because of its architectural details: an old linoleum tile floor and an Islamic shelf built into the wall. My installations are personal responses to spaces executed on-site in a direct, intuitive manner. My concern is with the wall as architecture; to me it's a refuge of willed silence, an act of enclosure, monumental yet at the same time speaking of privacy and seclusion. My concern is gesture, architectural details, the spirit of places. In this piece I wanted to convey the evocative power of a space through memory—its displacement in another time and place. I am concerned with displacement, being myself a displaced person; I want to transfer the spirit of one room/space and bring it into another. Listen to the room, what does it tell you?

I want my installations to be fleeting, what people are left with. I was excited because this hotel room would be my first permanent installation, to be rented eventually by different occupants. Somehow the piece would change with each new occupant. This was not the neutral space of a gallery; it was like a collaboration between artist and each successive occupant.

The piece consists of a wall drawing, written text, and photographs of Fort Lallemand in Algeria, which was used by the French as an interrogation and torture centre during the Algerian war of independence. This room installation was a personal political statement on the nature of oppression, imprisonment, and resistance to colonialism, based on my personal response to the energy in the fort in the Sahara. The fort was full of pain and doubt. My piece is a response to that struggle.

You enter the small room, seeing the outside of the fort; as you move around the room you become a prisoner detained in the room, looking out through the window. This is a piece dealing with the metaphor of interior and exterior.

I worked with text from my own diary, my strong personal reaction to the space when I was there in March, 1983. I also incorporated text from Jean-Paul Sartre's introduction to *The Wretched of the Earth*, by Franz Fanon. I speak of the horror of the space, what I felt coming out from the walls—the pain, then the healing sand, the Sahara taking over this vacant fort and cleansing it with the emptiness of the desert. In this piece I have simply tried to reclaim space through gesture.

New York, N.Y., United States

Hotel Room No. 31, Embassy Hotel, London, Ontario (1984)
Wall drawing installation
Photo enlargements, wax, dry pigment, Vaseline, graphite
powder, pencil and sand
18.58 m²
Photographs courtesy of Grünwald Gallery, Toronto; Wyn
Geleynse, London

Harold Klunder

b. 1943, Twello, Holland

I like this painting because it seems to be transitional.
My work until 1979 had been abstract with large,
geometric shapes. I dealt with figuration almost as
though the figure was in the closet or I was trying to hide
the fact that there was some figuration in my painting.
Around 1980, the figure started to emerge more obvi-
ously and it's almost as though in this work I'm trying to
bridge the two—I'm trying to deal with surface, figure,
and ground all at the same time, not seeing one behind
the other. Technically, the work is more traditional in
the paint handling. There's less splashing of paint, more
direct paint handling.

The painting also feels to me like a breakthrough in
that I had done an earlier self-portrait, *Tree, Wheatfield,
Mountain (Self-Portrait)* (1980–82), now in the Art
Gallery of Ontario, Toronto. But this one is more of a
self-portrait, not in the sense of an accurate copy of
something but as a painting of my personal feelings. It's
not a realistic look at me but a capturing of the vibra-
tions or the person that I represent emotionally.

The work is one of a series of three. Something about
the first one caught me, since I suddenly was able to mix
space and figure in a way that made sense to me.

Toronto, Ontario

Poet's Garden #1 (Self-Portrait) (1982–85)
Oil on canvas
198.0 × 198.0 cm
Private collection, Toronto
Photograph courtesy of Tom Moore, Toronto

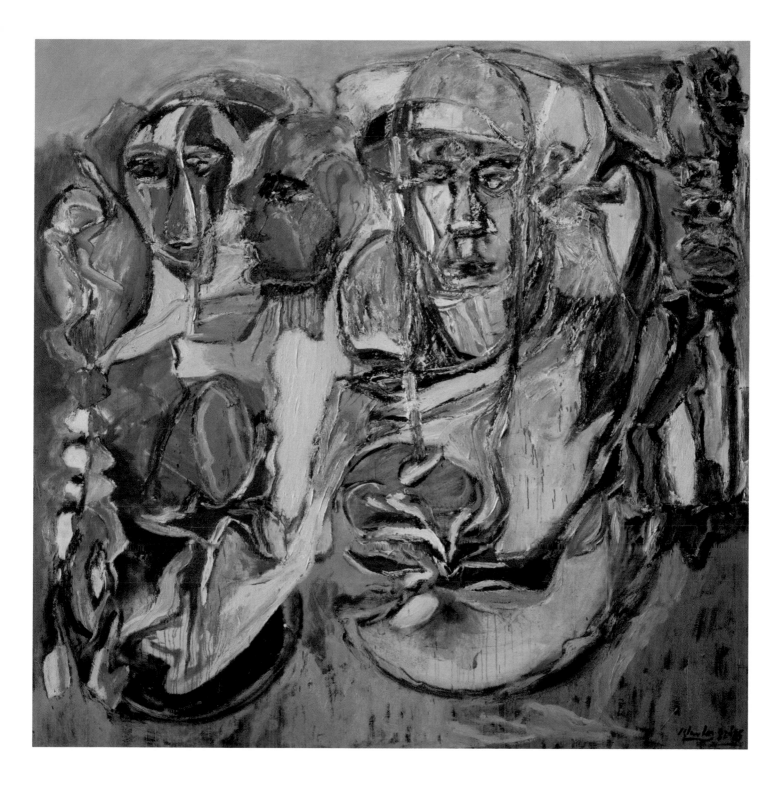

Dorothy Knowles

b. 1927, Unity, Saskatchewan

This picture was originally intended as the left side of a
three-panel painting. It was painted with acrylic paint,
as were the other two panels. However, the paint on this
one had a different feel to it—something like oil paint.
So I separated it.

I like the way the trees come out of the bottom of the
painting. As a result, it feels like you're more a part of
the picture, rather than simply looking at it. The tree
branches also set up a grid with the background and it
prompted me to do more paintings like it—using a grid
as a basis.

Saskatoon, Saskatchewan

Trees by the River (1986)
Acrylic on canvas
198.1 × 198.1 cm
First City Capital Markets Ltd.
Photograph courtesy of Waddington & Shiell
Galleries Ltd.; Tom Moore, Toronto

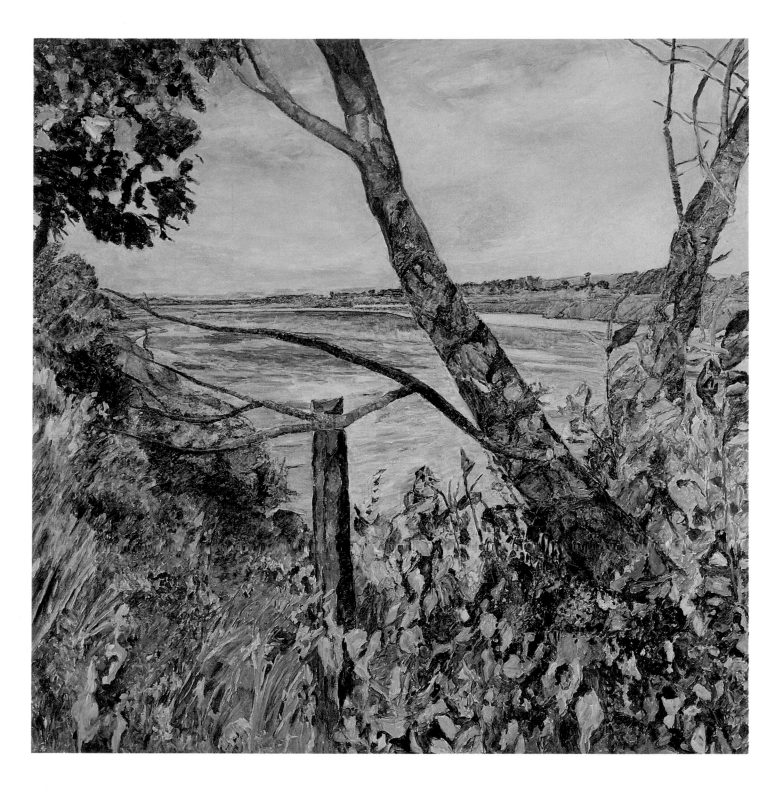

Wanda Koop

b. 1951, Vancouver, British Columbia

When I was a child I liked going to the cemetery close to
my home. It was large, heavily wooded with a tall iron
fence around it. I spent many hours looking at the
flowers and wreaths and studying the stones, imagining
about past lives. Sometimes I would find sealed bottles
of liquor neatly placed on the grave. The grave tender had
a small pony that pulled a huge wooden wagon—I would
follow as they made their rounds, hoping to catch a fallen
flower or, even better, part of a broken wreath. I remem-
ber thinking that my treasures had a peculiar musky
smell and that by keeping them I was touching life and
death.

Years later, while travelling on a bus to northern
Manitoba, I saw a new grave at the edge of an open field.
It was dusk and a thin layer of snow covered the mound.
As we moved past the last light caught the brilliant pink
flowers of the wreath.

I returned home and began a series of drawings called
"symbols and associations" which led to a series of
paintings, one of which contained the wreath image.
Since that time the wreath has been a recurring visual
element in my work. This work is part of a large collec-
tion of preliminary working drawings done in 1984.

Winnipeg, Manitoba

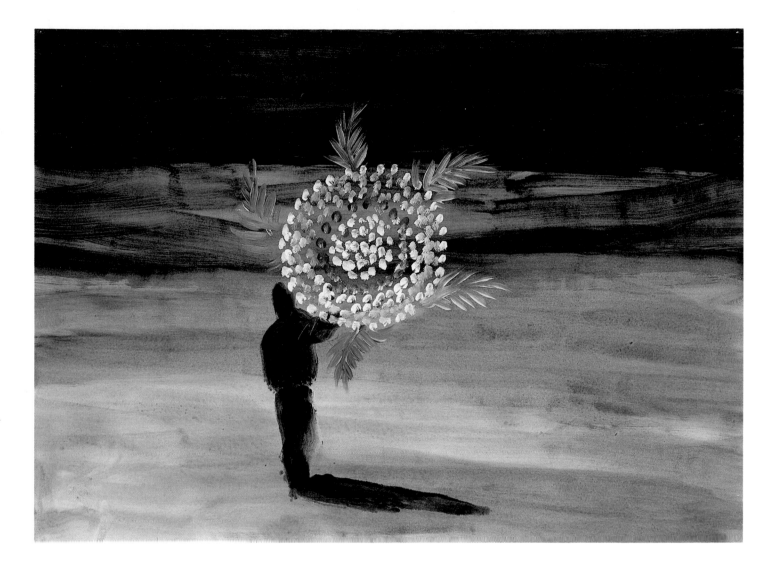

Shadow Man With Wreath (1984)
Acrylic on Stonehenge paper
55.9 × 91.4 cm
Private collection, Winnipeg
Photograph courtesy of Sheila Spence, Winnipeg

Joan Krawczyk

b. 1951, Windsor, Ontario

I started painting, as some people say, from the womb. I can't remember a time that I did not paint or draw.

I was born in an ethnic neighbourhood where each house spoke a different language and each dwelling contained more than seven people. It was a complex world for a child, with no set form for communication. It was exciting to go to my friends' homes where the smells and the furnishings were different, if not outright strange. In these homes of many adults, everyone contributed to the décor, adding personal belongings from the old country and their own idea of aesthetics. Our home had holy pictures placed very high, close to the ceiling, and a "modern" landscape over the sofa. Visitors said it was a very good painting. I did not agree: it was bland. I preferred the holy pictures of the people bleeding, their skin creamy-white, their hair long, flowing, naturally curly. My family had the same light-coloured hair but not the features, except for my sister. I never thought myself attractive because my looks were so bumpy and my hair so very straight. The other neighbours had even stronger looks and different coloured skins besides.

It came as no surprise to me in the late 1970s when I started painting portraits. These started out in a genre vein and changed to icons. People make god images in their own image and this image changes styles almost as often as they do. People adjust their image to the style of the day and to the kind of response they wish to receive.

The large portraits were ironic in that I wanted the very best of the person, the one perfect moment when all that they were would show, with no apologies. I control everything about the painting—the light, the sitting, the clothing, and the make-up. The colour is further controlled in the painting process.

In *Midnight Men* eventually I added another face and the work changed to be about relationships. The large scale forces the viewer to take part in that relationship. Perhaps at this point I see the relationship as god-like. The fascinating thing about group paintings is the repetition of situations, how people either behave in an habitual fashion or situations repeat themselves. Now the face has disappeared altogether and the work becomes more about universal matters, more about morality, economics and political concerns.

My work—that of a person with ethnic roots brought up in the media age—changes, matures, and evolves as I do. My work chronicles my life; it is a diary of all I know, of my friends and the people who influence my life. Painting is a human experience and humans need, I need, the input of people, news, magazines, movies and, of course, relationships.

This painting was chosen because I see it as a transitional painting. It involves all of my concerns and literally turns its back on portraiture.

Toronto, Ontario

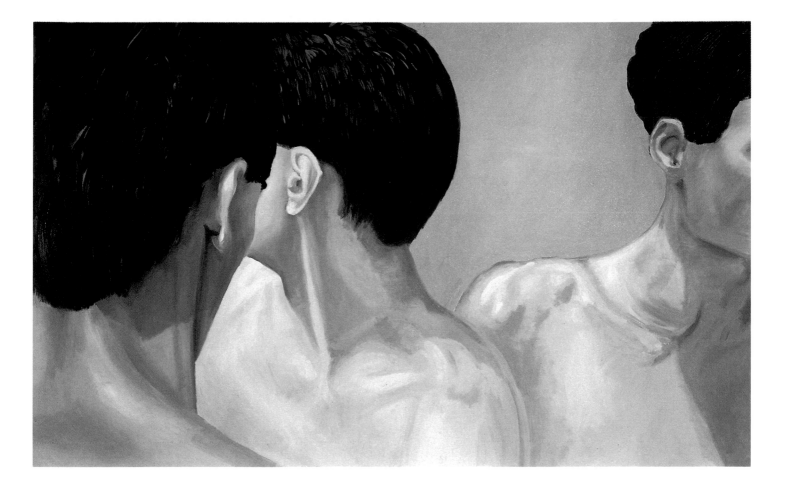

Midnight Men (1986)
Acrylic on canvas
152.4 × 243.8 cm
Dr. Miles Cohen, Toronto
Photograph courtesy of Jeff Nolte, Toronto

Jean Paul Lemieux

b. 1904, Quebec City, Quebec

I did this painting because I thought it would be good to have people see a nuclear winter. It's difficult to convince people what the world would be like with a nuclear winter. This could be July. I painted this in the spring or summer.

I began making a lot of wash drawings last spring. Turpentine and colour is an effective medium. I did a painting of this subject too. In this work I painted the first man with no arms. Then I added arms. You can see the cut in the elbow. The monument doesn't exist— notice, it has no sword.

One person who meant a lot to me was Edvard Munch. His *Cry* is very strong. This has a little of the same feeling in the frightened expression of the eyes.

Of course, there's nothing you can do about a nuclear attack. But if I show paintings like this one, humanity might get the message.

Quebec City, Quebec

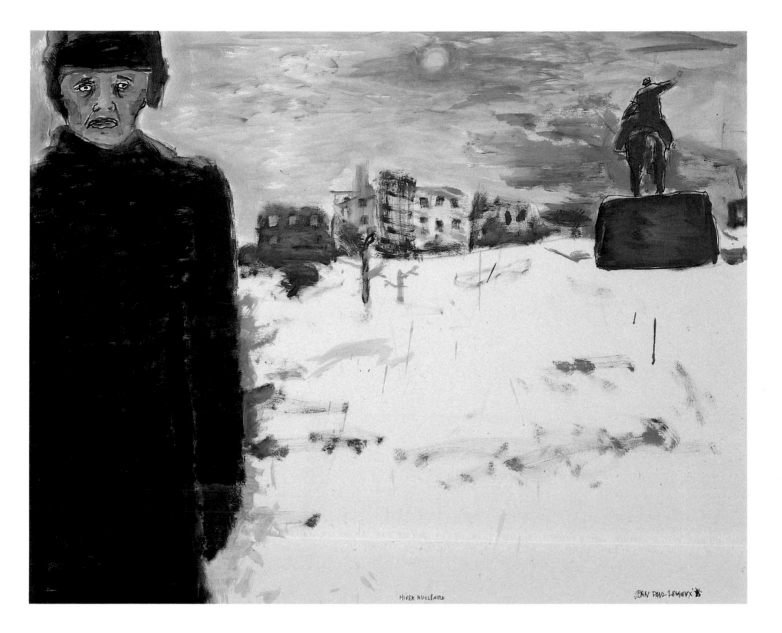

Nuclear Winter (1986)
Oil paint and turpentine on paper
78.7 × 99.1 cm
The artist, Quebec
Photograph courtesy of Patrick Altman, Musée du Québec,
Quebec

Rita Letendre

b. 1928, Drummondville, Quebec

What I'm doing now is a summation of my work of the 1950s and early 1960s, combined with passionate colour. In the late 1960s, and 1970s, I learned to discipline myself. That helped me gain control of my painting. My most recent work uses the airbrush. In some works I use oils for an effect of vast space and openness. Some people say that I have returned to emotion in my painting—I don't know. Perhaps I am showing more of myself.

Toronto, Ontario

A Recurrent Dream of Mine (1986)
Acrylic on canvas
153.0 × 107.0 cm
The artist, Toronto
Photograph courtesy of Tom Moore, Toronto

Ernest Lindner

b. 1897, Vienna, Austria

This is my favourite drawing because at first glance
everything in it is well-matched, but if you have a closer
look, you'll see that there is a distinct difference
between the parts. For instance, look at how the toes
separate and how the fingers don't meet. It was well-
balanced. Perfect without any effort. One day it just
happened.

Saskatoon, Saskatchewan

Resting (1975)
Pencil on paper
74.3 × 54.6 cm
Norman Mackenzie Art Gallery, Regina
Photograph courtesy of Don Hall,
University of Regina, Regina

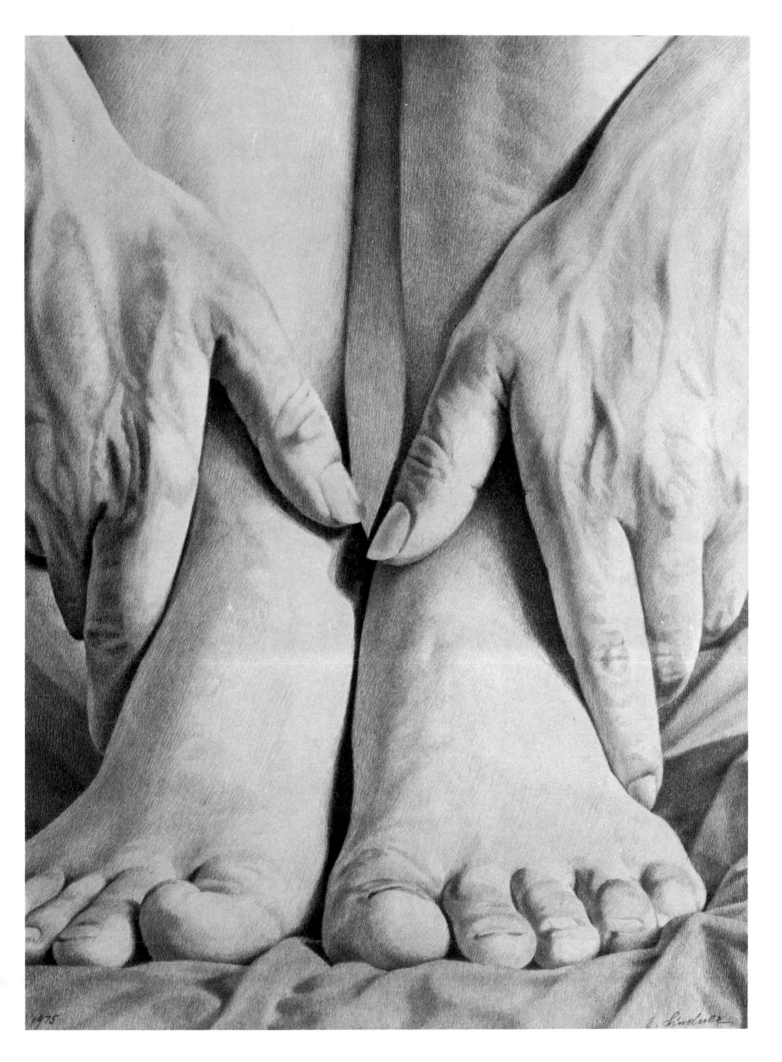

1975 E. Lindner

Glen Loates

b. 1945, Toronto, Ontario

It was far too cold to work outside that day, so I found myself sketching for more than two hours in the front seat of the car with the window half opened and the engine running for heat. At this point I had drawings scattered on the front and back seat of the car, not quite the picture people would envision of an artist at work. I had nearly completed the drawing before a common crow entered the landscape, hovering silently on updrafts. As a brush of colour adds life to a painting, the crow's entrance added a sense of realism and the drawing took on a whole new dimension. I quickly sketched it into place.

With my art I try to provide an intimate experience of the subject in its environment. I felt it was important for the viewer to feel the sweep of the crow's wings and to soar with him in flight. The bird was very much a part of that grey sombre day.

One could say this drawing is a composition of contrasts, where the crow's own vitality and strength seem to be at odds with the barren trees and the brush of the landscape. The crow commands a sense of strength with his wings fully extended. His curves and soft appearance seem to contrast the angular formations of the ground beneath. The landscape, consisting of quick angular strokes, in accord with the free spirit of the land, has been loosely drawn; these barren and twisted trees reflect their relentless struggle with nature. I tried to create an effect by using the eastern white pine on the left of the drawing to balance the crow, both in density and strength. The negative spaces in the landscape, I feel, create soft visual movements carrying the viewer through the drawing. The final details of the crow were finished at the studio with the help of a spread wing borrowed from the museum.

My drawing complete, I was satisfied that both emotional expression and precision of detail were captured in one.

Maple, Ontario

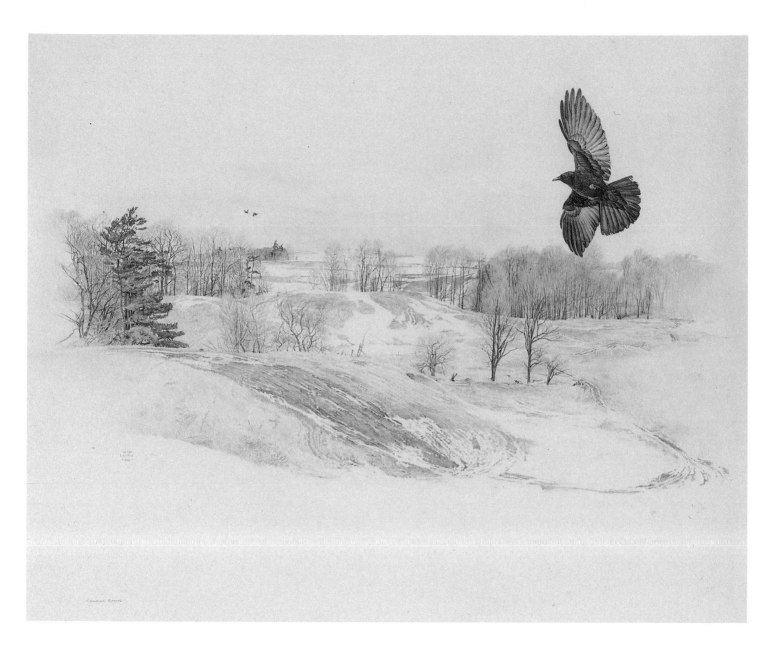

The Common Crow (1980)
Graphite on paper
78.7 × 91.4 cm
Private collection, Markham
Photograph courtesy of TDF Photography, Toronto

John MacGregor

b. 1944, Dorking, England

We are at the threshold of a period of rapid change in society and culture. Many analysts have written of the shock of the future, a new future to which our historical culture will be irrelevant. "Opportunity will go to those individuals who are *future-oriented* in an increasingly *universalistic culture.*" (John Porter, *The Measure of Canadian Society: Education, Equality and Opportunity* (1979))

The new orientation calls forth a new idea of the individual. In the context of world-wide urbanization, socially and physically the close-quartered urban space gives rise to a myopic personality. Somewhat akin to, but also different from, the space depicted in historical Japanese, Chinese, and early Medieval European art, it is the human space where *individual* means being a part of a group. It will increasingly become a collective space tending toward a universalistic culture.

In pictorial space, we are approaching an era of a new cartography of body and spirit. In one sense it is the beginning of the end of the cartography of Paolo Toscanelli, the Florentine whose works influenced the conception of Renaissance pictorial space—no more conceptual snap shots of time, no more putting a moratorium on a selected view of time and space, no more frozen bodies in a frozen space. Now we have an interaction of different spaces, objects, and times. In the new art living space defines the objects rather than the converse. It is a new way of looking and of understanding ourselves and the world we live in. In one sense it is the social space of non-being, not in the sense of nothingness but in the sense of not being any particular part.

The painting *Storm Over Casablanca* expresses some of my feelings about this new social space. Like all forms of art, the new art has certain potentials and limitations. It goes beyond the present forms of individual and social censorship and guilt that many artists find themselves involved with. In one way it allows the artist to think and create differently. But in another way it also alienates the artist from present-day society and its past cultural history. The new art represents to me the attempt to maintain the dignity and integrity of the individual human spirit in a future that will increasingly become more and more threatening to that spirit.

In many respects science has become the new religion of our times. The new art does not totally deny the influences and importance of modern science, but it does express strong reservations relating to the social and spiritual limitations of this field of human endeavour. Therefore, the new art is somewhat at odds with today's scientific, rational way of thinking.

If we are going to develop the essentials of what it is to be civilized, contributing, loving human beings in a future that will see the development of robotics, genetic engineering, artificial intelligence and so on, then we must support this new art. We must encourage those individuals in society who are questioning in a different way the purposes of our future existence.

Toronto, Ontario

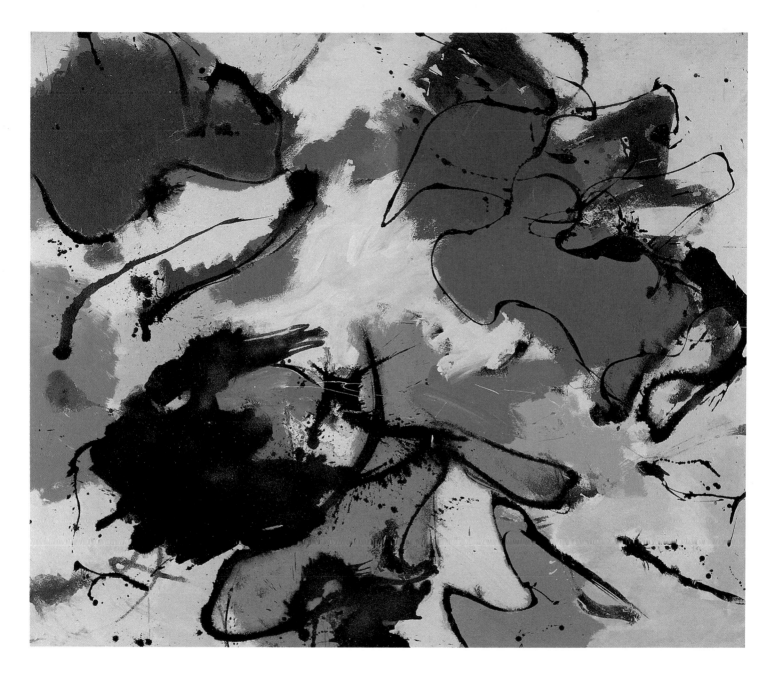

Storm Over Casablanca (1981)
Acrylic and sand on canvas
182.7 × 213.2 cm
Robert McLaughlin Gallery, Oshawa
Photograph courtesy of Tom Moore, Toronto

Liz Magor

b. 1948, Winnipeg, Manitoba

On the counter is a heap of fish, behind this a "Fish of the world" poster, and in the corner a fisherman hoists aloft his steelhead trophy. Around these images, in a found text, two sisters, Kathleen and Madelaine, synchronize and separate. Kathleen, though not yet "hoist aloft," has put herself in jeopardy. Alerted by the modest signs of her difference an observer comments that she is "more affected in manner than Madelaine," outlining in absurd detail the evidence of her vanity— her nails, her hair, her writing ink. Harsh treatment for a little aesthetic pleasure. A punishment perhaps for daring to be single when she is identified as "twin." In either case I empathize with Kathleen and I wanted to represent her dilemma. With the sleep of sameness on one hand and the danger of difference on the other, I have left her suspended. I picture her at her writing desk with her fringe of hair and red nails, wondering how to continue her process of self-identification. Schools of fish are the images in her mind.

Toronto, Ontario

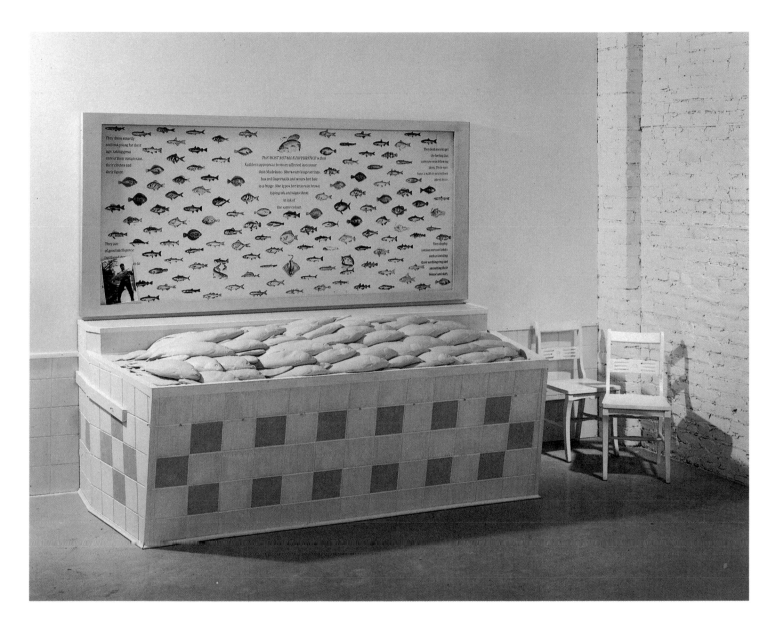

The Most Notable Difference (1984)
Silicone, rubber, photographs, wood
210.0 × 350.0 × 124.0 cm
The artist, Toronto
Photograph courtesy of Ydessa Gallery, Toronto;
Robert Keziere, Vancouver

Jean McEwen

b. 1923, Montreal, Quebec

Friends of mine were laughing at a painting I made and dared me to send it to the spring exhibition at the Montreal Museum of Fine Arts. I did submit the work in 1948 and had the surprise of my life when it was accepted. After that, of all the dreams I had, I decided to pursue the one of being a painter.

Around then I did a show half figurative, half not. But after that, in 1949, I went to Paris to find out what art was all about. I then became a non-figurative painter.

Montreal, Quebec

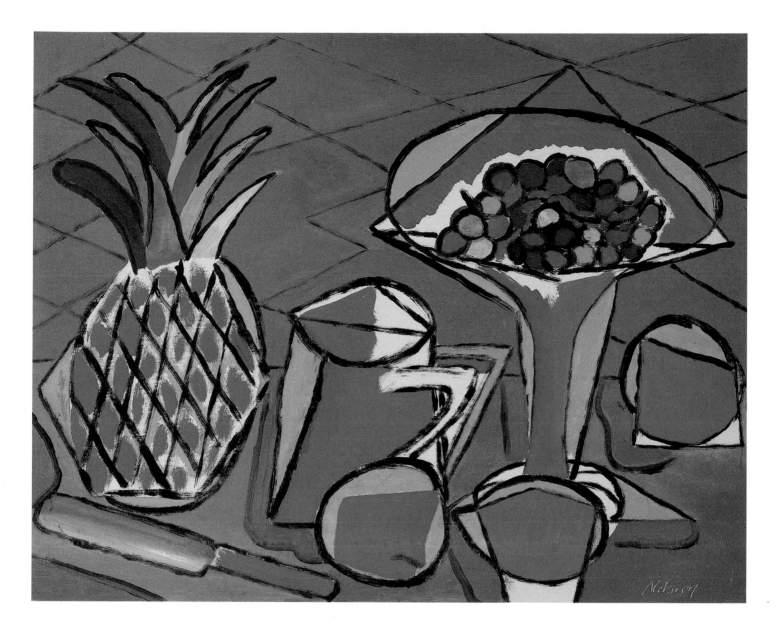

Still-Life With Pineapple (c. 1945)
Oil on canvas laid on board
40.6 × 50.8 cm
The artist, Montreal
Photograph courtesy of Yvan Boulerice, Montreal

Al McWilliams

b. 1944, Vancouver, British Columbia

For the first three months of its development this piece was taking an entirely different form: no ring, no chairs, and no potential intimacy. Developing the piece was a process of battling against myself and my own history and concerns as an artist. My problems arose, to a degree, from giving too much credence to the predominant attitude that public art is a solution to a problem, its social responsibility seen to be enhancement and decoration rather than the stimulation of physical, intellectual, emotional, spiritual, and critical responses—responses that are more and more frequently being designed out of our urban environment.

Those three months were not squandered. The doubts and false starts allowed me to centre myself more clearly and to move more naturally with the forms I know. Not only did the space of the TD Centre plaza become an unconscious part of my vocabulary but also I was able to realize more clearly that public art need vary only minimally or not at all from gallery or installation art—minimally in formal terms, due to context, and not at all in range of content. At a certain point one excludes all relationships with the outside; the only responsibility is to the work.

This piece is located in the King Street Plaza of the Toronto Dominion Centre in Toronto, and works within an essential space of 51.8 × 65.5 m. It consists of a bronze ring 9.14 m in diameter and 10.16 cm thick, standing 2.74 m at the highest point, 2.13 m at the lowest, and leaning at an angle of 3.75° towards the vertical aperture at the low point. There are three openings 91.4 cm wide cut from the ring at the angle of the slope, giving access to the interior. The surface of the ring is patinated a green reminiscent of classical Greek bronzes. Three oversize bronze chairs, standing 1.52 m high and patinated black, are precisely aligned with the openings in the ring at varying distances from the perimeter.

Vancouver, British Columbia

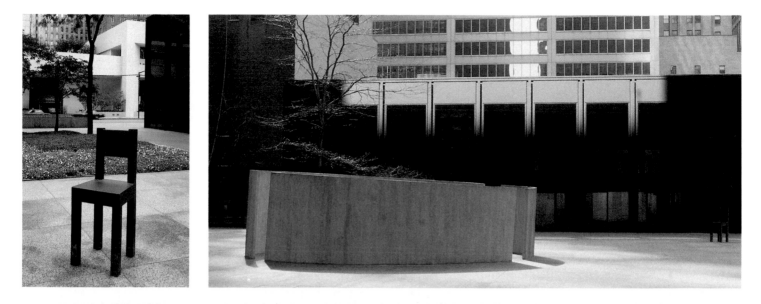

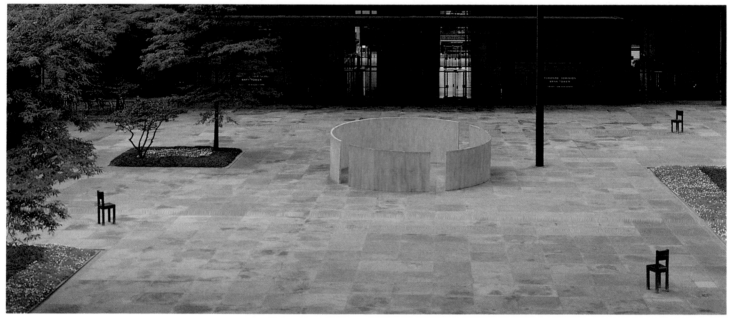

No title (1985)
Bronze
51.8 × 65.5 m
Toronto Dominion Centre, Toronto
Photograph courtesy of Robert Keziere, Vancouver

Ray Mead

b. 1922, Watford, England

Perhaps the title *Door* has a metaphorical meaning, inasmuch as it was a door for me to pass into a new era of experimentation. Earlier I had painted a series of canvases that were almost totally black except for images and shapes around the edges. After this series everything was set for me to execute a new series of paintings where everything was abandoned, apart from the essentials of the canvas. Even the proportions of the canvas were important—its scale and size. The aim was to say this to myself, "Here is canvas and nothing about it must ever be destroyed, so that anything marked upon it has to always have the feeling of the whole and sometimes to enlarge the appearance by the large simple shapes and colours spread upon it."

At first the results seemed frighteningly simple in appearance, but, looking at them standing against the wall in my painting area, I came to realize that as a group of paintings they were working in a powerful and simple way. At times I looked at them in almost total darkness and at other times in bright light to make sure that the feeling each painting was giving by means of its scale was that of a true painting. The essential thing was to maintain the reality of the painting and to make certain that it did not owe its being to transient effects of colour and constant light changes, that it had a reality within itself.

The *Door* was painted in a work area where the ceiling was rather low. The canvas was fixed to the ceiling and to the floor so that it was unmovable while the work was in progress. I can remember spending long periods of time with my head between my legs in order to look at it upside down, or lying sideways to see it from other positions.

The reproduction will miss some of the tonal changes within the dark area, but these don't matter as much as I thought they did at the time; the painting still maintains the sense of bigness with simplicity that I wanted to achieve. I also remember the excitement of putting the orange mark on the right. This immediately controlled the painting and kept it well within the framing on the right side. It also took the eye behind the black to come forward again in the light ochre area on the left. By doing this I was able to take the oval shape and put it in the position that appears to be a short distance behind the large dark mass, thus giving the painting a controlled depth of field.

Door was the beginning of a long journey, which is still continuing. When I look at the time between and remember all the excitement that I have had and the significant changes that I have made, I realize that, in part, I am using the same mental attitudes toward the canvas that I developed many years before. With my most recent paintings, the better I get to know them and explore my reasons for painting them, the more I realize that one human being has only so much within him or her and travels the same journey in the same body for many years.

Toronto, Ontario

Door (1960–61)
Oil on canvas
203.4 × 173.3 cm
Robert McLaughlin Gallery, Oshawa
Photograph courtesy of Tom Moore, Toronto

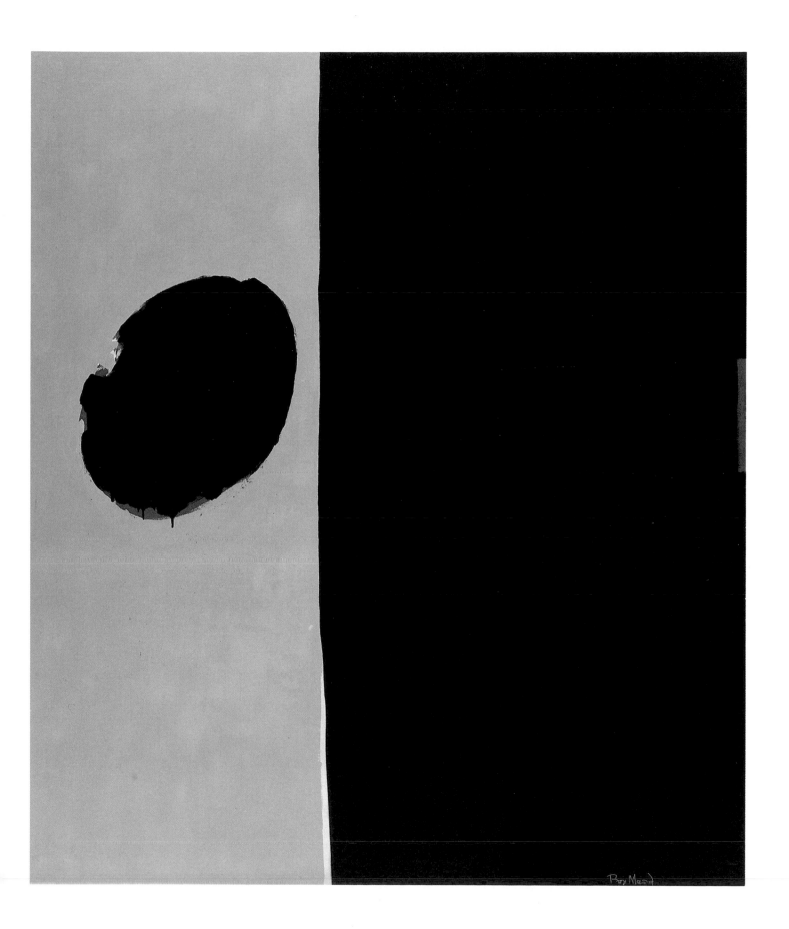

113

John Meredith

b. 1933, Fergus, Ontario

I could have picked five others but I just figured I'd pick
this one. I did it just after the Kennedy assassination so I
kind of felt it was for Kennedy. The background is bril-
liant red, then there's bright blues, bright greens.

Toronto, Ontario

Crusader (1964)
Oil on canvas
193.0 × 243.8 cm
Private collection, Toronto
Photograph courtesy of the Art Gallery of Ontario, Toronto

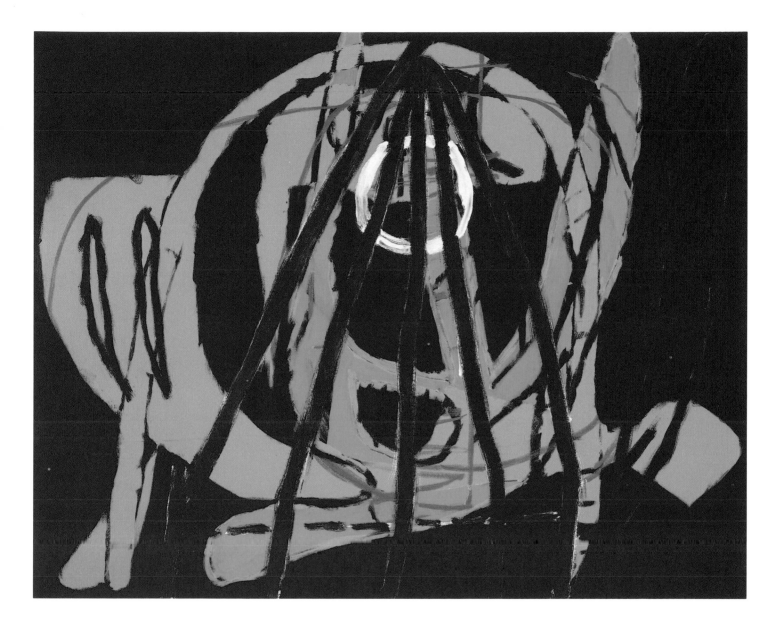

Janet Mitchell

b. 1912, Medicine Hat, Alberta

I begin with a vague idea of a subject, a continuation of
my stream of thought. I have worked continuously in my
life at painting, even in the years when I needed to work
in an office for my living. Through work, I have made
my own discoveries about painting and about myself. I
have arrived at a stage where the less deliberate control I
have, the better the results. I studied hypnosis from a
medical doctor and I believe that has some bearing on
my approach to painting.

Calgary, Alberta

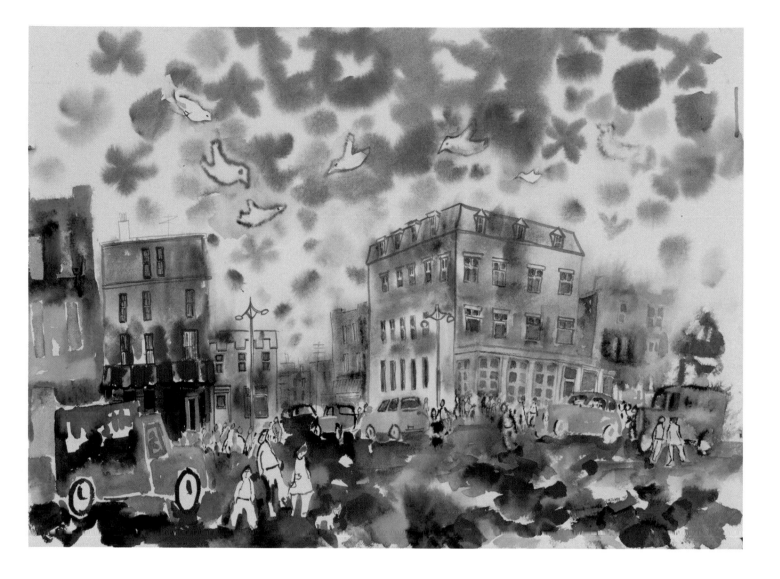

Big Town (1975)
Watercolour on paper
53.4 × 74.0 cm
Peggy and John Armstrong, Calgary
Photograph courtesy of Masters Gallery, Calgary

Guido Molinari

b. 1933, Montreal, Quebec

The execution of a group of works in 1951 resulted in my interpretation of a "principle of destruction" as a basic concept of painting, akin to that once articulated in a letter from Mondrian to J.J. Sweeney. I was conscious that the true subject of painting is but the explication of a somatic universe.

In particular, I discovered in these first works that they contain, at the level of a painting's very surface, an operative process that instantiates two principal zones but in an asymmetric and contradictory way. This compositional matrix is brought into being by a chain of proportions that place in evidence the function of laterality and the energy of the painting's periphery.

This elaboration of surface relations takes account, in its very dialectic, of a fundamental somatic energy; the different modes of being, so to speak, that these relations inscribe on our bodies.

In 1955, in the picture entitled *Emergence*, the dynamic principle of asymmetry is stated in the way it creates a "tachiste" white plane functioning like a vector which divides the whole field into two unequal parts. The lateral masses of yellow, green, and red create a scale of oppositional variations that are reabsorbed by the luminous energy of the central vector. Under lateral pressures, these are constrained into a left/right motion and a back-and-forth "pulsating" effect.

Through the elimination of chromatic tonalities, the serialization of whites and blacks in *Tri-Noir* (1955) generalizes the energy of the central vector and the transposition of peripheral energies. This engenders a radical new *reversible* spatiality, in a constant oscillation between these systems of opposition and the dynamism generated by their juxtapositions. It is in *Tri-Noir* that I began the exploration of the infinite possibilities of "reversible" space. This exploration has dominated my researches for the last thirty years.

Montreal, Quebec

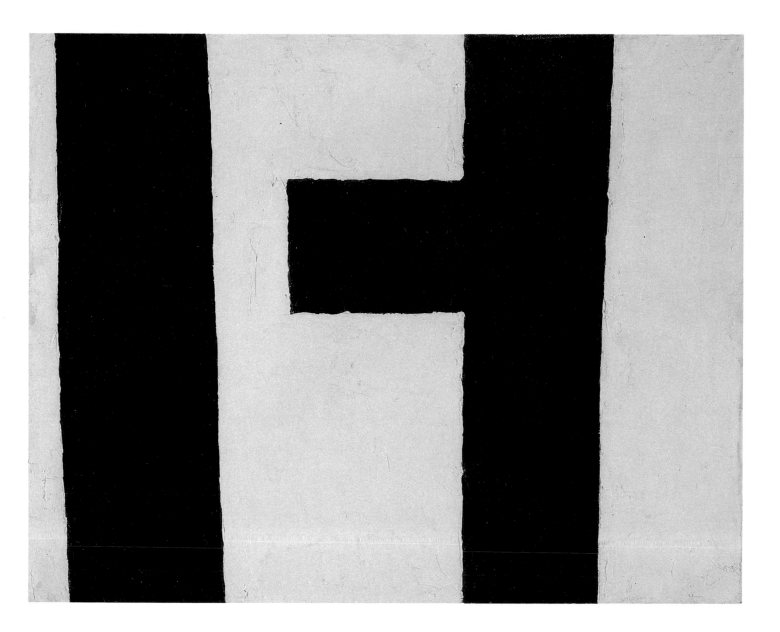

Tri-Noir (1955)
Oil on canvas
76.2 × 91.4 cm
The artist, Montreal
Photograph courtesy of Yvan Boulerice, Montreal

Carroll Moppett

b. 1948, Calgary, Alberta

Sculpture is for me stubbornly visual and physical, naturally less inclined than painting to either narrative or narcissism. Three-dimensional form itself seems to me secretive, very nearly mute. It allows me to work in a way that's not literal but acknowledges my debt to both the landscape and sculptural traditions. After being inside a piece for a long time—thinking, building, and changing everything—I no longer imagine that my own perceptions of it will coincide with those of anyone else, so involved are my perceptions with my own desires and so sure am I that every viewer has desires of his own. Imperative information then is not my concern, but leaving room for the viewer within a dense construct is.

The artist can, as Cézanne said, "give concrete form to his sensations and perceptions"; in this way he marks tangible points along his way so as to deny chaos. *Figure 5* marks a particularly sculptural point for me, evoking artifact, animal, landscape, and figure without disassociating from its materiality. It pretends to be innocent, interested perhaps in aesthetics; it plays with my suspicion that what I really want to find when I am done is, simply and impossibly, beauty. At moments it seems completely ugly, brutal in its dissynchronism; at others it triggers memories and sensations that are so elusive I find it impossible not to believe in the work's completeness. It is particularly as an exploration of sculpture that it remains pertinent, even though forms change as new curiosities grab my attention.

Calgary, Alberta

Figure 5 (1985)
Wood, wax, plaster and oil, enamel, and watercolour
63.5 × 30.5 × 15.2 cm
The artist, Calgary
Photograph courtesy of Tom Moore, Toronto

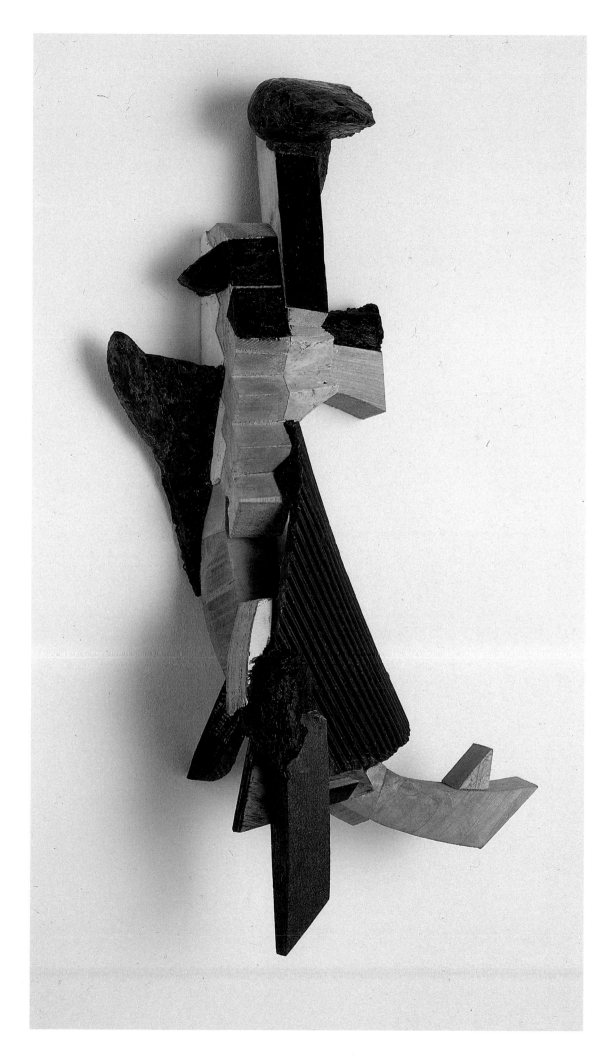

Ron Moppett

b. 1945, Woking, England

I have chosen this picture because it is a summation and a beginning. It is a précis of earlier work and in many respects a model for the work I'm doing now. Of course, what I'm doing now has to do with most of what I've done but there is something rather "finished" about the works that precede this. Perhaps they now seem too circumscribed by the anecdotal? Not dead, but removed from that special condition of work still functioning in the studio.

In many ways *Blood/Light/Angel (1)* is a typical painting for me even if the religious aspect is more obviously to the fore. It is formally complex, an aggregate of visual signs, stylistic collisions, ambiguous spaces, and apparent contradictions. I've thought for a long time that the way I present information is very sculptural. One has to carry information rather than just look at an image. Meaning is gathered in a more elliptical fashion. Co-existent in time and space, the images suggest the simultaneity of a dream in which a web of conscious and subconscious experiences comes together. Meaning, abstract and allegorical, exists in the space between images.

The teddy-bear angel comes from the most pedestrian source, a Christmas gift-ideas magazine. I responded to a dumb image that is aspiring in its pathetic way to the transcendent. I had at the same time been looking at some very large paintings by Rubens in New York's Metropolitan Museum where the huge frames also included relief images. Quite different from a painting in frame. The way this painting arranged itself in an eccentric form, like a vignette, allowing each section to be more discrete, was really a breakthrough for me.

The bottom horizontal section contains references to the figure, landscape, history, and time. The square panel above it is actually velveteen fabric with painted blue spots and the Greek prefix AE. It alludes to a shroud and a sky, having both an optical spaciousness and yet a real material presence. The embryo-like silhouette at right is ambiguous as a figure. It suggests birth and death, animal and human, and is at odds with the definity of its shape. Above it all is a small teddy bear with a cloth skirt, paper wings, and pipe-cleaner halo. The picture reverses its subject matter: a simple doll/toy angel above and a very abstract painting below.

Being more sculptural and less cinematic it is, I think, more coherent and less narrative than many of my works. It can function as a meditation on mortality rather than being forced into the symbolic at the service of narrative.

Calgary, Alberta

Blood/Light/Angel (1) (1986)
Oil on canvas with mixed media
236.2 × 229.2 cm
The artist, Calgary
Photograph courtesy of John Dean, Calgary

Joey Morgan

b. 1951, Yonkers, New York

Souvenir: A Recollection in Several Forms was important to me for its complex structure, which allowed me to extend and overlay several concerns within a single piece.

Souvenir was presented in September 1985 on the thirty-first floor of Park Place office tower in Vancouver. The project consisted of a preliminary mailing, a video installation, VideoPerfume, and two audio installations, *Murmurings* and *Oratorio*. The piece follows conceptual concerns developed in previous projects: variables in overlaying physical, temporal, and spatial data; the shifting relationships of art, narrator, and audience; the repetition and counterpoint of overlapping parts; and the interplay of context, circumstance, and implied or fully articulated elements in the overall perception of the piece.

The viewer arrives at the centre of the installation by using a high speed elevator.

VideoPerfume: The video image looks over the shoulder of a single passenger on a freight elevator as the car glides up and down without stopping. Some floors are visible; others are blocked by outer steel doors. As the car passes one particular floor, the Chopin Nocturne opus 9 no. 2 in E-flat major can just barely be heard. Excerpt from text:

> When she was ten years old her mother died after a long illness.
> The house had been quiet for years,
> and she had only been able to see her mother at certain intervals,
> intervals of remission when her mother was strong enough.
> Memories of her mother before the illness seem remote and unclear:
> some of them memories of sunshine and singing,
> and some of them memories she had been told so often, they were
> The Official Family Version,
> that she assumes they really are memories,
> although it's hard to be sure.
> This bottle had been on her mother's bureau when she became ill.
> And then the house got quieter.
> And then her mother died.
> So as a young girl my mother inherited the perfume bottle
> along with the more traditional pieces of a legacy.
> One day the glass stopper broke off clean at the neck.
> Or maybe that was before her mother died? She's not clear.
> But now the bottle has always been among her own things,
> lined up in the rows of perfume,
> and sometimes, glancing, she notices it and wonders
> if that particular smell would trigger a
> flood of inarticulate sense memories of her mother
> and her own forgotten childhood.

Souvenir: A Recollection in Several Forms (1985)
Installation, Park Place Vancouver
The artist, Vancouver
Photograph courtesy of Robert Keziere, Vancouver

Murmurings: A series of freestanding doors held in position by cables and metal braces. The wood surfaces of each door have been worked in a variety of materials: wax, verathane, oil paint, chalks, graphite. Passages from the VideoPerfume text have been rearranged and handwritten on each door. A small colour transparency in the centre of each door's window section refers to each movement of *Oratorio*. The sixth (final) door has been set in a partially finished steel stud and gyproc wall and sealed shut. A piano practice session of the Chopin Nocturne opus 9 no. 2 can be heard throughout the installation.

Oratorio: This section is installed between corner windows overlooking English Bay and the mountains. A piano soundboard and other piano parts are surrounded by piles of crushed glass. A fifteen-minute audio score is heard detailing a chronological account of the soundboard's demolition:

- final phrase, Chopin opus 9, no. 2 in E-flat major
- piano slowly pried apart
- waves under Jericho Wharf (transitional)
- soundboard played underwater, recorded underwater
- soundboard played by rats scurrying across the strings
- soundboard played by heat from propane bar and on fire
- .44 Magnum bullet shot through the soundboard, piercing a single string on the other side.

After thirty seconds of silence, the audio tape begins again.

Vancouver, British Columbia

Louis de Niverville

b. 1933, Andover, England

Les Noces is based on my brother's wedding in the early 1950s. It was the first time I'd ever been to such an occasion. As a kid, you're there wide-eyed, looking at everything. The night before he got married we had the most incredible snowstorm—four feet of snow. Lots of friends were invited but only the family made it to the church. But afterwards, everyone came to the reception at the Ritz Carlton in Montreal. They all made it for the party and *Les Noces* is about that party. What absolutely amazed me is how much people wanted to have fun. I had never seen such gluttonous people in my whole life and so aggressively hungry! Many times I attempted the subject of weddings and never succeeded. Finally, I arrived at this one and somehow it was exactly what I wanted to say. The colours are gaudy, there's too much food and champagne, the whole place is jumping. It's kind of a visual delight, and at the same time, I'm poking fun at it.

Coller means "to glue," so when I make a collage, I first paint lots of papers. Then I cut out shapes, arrange them in a composition, and stick them down with tape. Then I rearrange things, adding or subtracting shapes as I need them. When I'm satisfied that it all works, I glue them down permanently. It sounds very simple but it's not. It's a long, slow process. Some of the background was painted because I wanted softer edges than I can do with collage. And then it's all assembled and I use tape to stick the paper to the surface and then I try this and that, and I cut pieces, and I try another colour.

The wonderful thing about collage is that you can work at it for three weeks and destroy it in five minutes—but still keep the pieces. With a painting, you can work at it forever and you're always painting over what you don't like, but collage has a clean and direct look to it. The colours—because you're applying only one coat of thin colour on paper—stay bright. They're brilliant and they shimmer, and so the collage itself has that quality. And then of course, the papers can be pushed and moved around, so therefore you can really play with your composition. And maybe in a way, because of that, you can push your idea much further than you could have done by painting.

Toronto, Ontario

Les Noces (1984)
Collage on board
182.9 × 121.9 cm
Private collection, Toronto
Photograph courtesy of Tom Moore, Toronto

John Nugent

b. 1921, Montreal, Quebec

I had a dream. In the dream this work was important. In the dream the reasons for its importance were lucid—as clear as the water in Fairwell Creek.

I awoke and within seconds the dream began to fade. I grasped for the importance of the work. I invented meaning. The work was significant, symbolic, metaphoric, mythological, entropic. Artistic platitudes began to fog the vision. In truth the work was unimportant, unacceptable, unmarketable, outside artistic standards.

I chose this work because it was in a dream.

Regina, Saskatchewan

Kievokov (1985)
Steel
193.0 × 87.0 × 155.0 cm
The artist, Lumsden, Saskatchewan
Photograph courtesy of the artist, Lumsden, Saskatchewan

Toni Onley

b. 1928, Douglas, Isle of Man

On the glacier I am left with only the bare bones of landscape, sky, rock, and ice, with uncluttered mind and clear perception: all the conditions for creative work. Perceptual capabilities are sharpened in the mountains. The monumental expanse of rock and ice does something to the inner, the reflective. In such places the quiet is audible. The ring in the ears is the sound of one's own blood circulating. Above the timber line the painting is often painted for me. I am able to concentrate on what is essential.

To test the outer envelope of freedom is to be exalted and dwarfed at the same time.

<div align="center">Vancouver, British Columbia</div>

Forbidden Plateau (1984)
Oil on canvas
76.2 × 101.6 cm
The artist, Vancouver
Photograph courtesy of the artist, Vancouver

Andrew Owens

b. 1950, Holyhead, Wales

People "at the top" are attracted by power. We live and work in angular buildings because powerful people are attracted to plans that call for angular "masculine" forms that traditionally symbolize or embody power. Our central planners like to litter our downtowns with phallus-formed head offices. Except for the occasional vaginal-formed sports stadium, we're living with architecture that is female-disqualified. But the female principle won't go away. Though ignored it continues to exist, often unseen and unexpressed by society, an underbelly to history.

Jung proposed the existence of a feminine aspect present in the unconscious of every male, calling it the *anima*, a collective or social feminine principle which a man doesn't even want to think about let alone express.

In 1982 I began work on a piece about the feminine archetype, the original idea or principle that leads to the feminine aspects of forms of expression. Archetypes were a component of this computer graphics piece, reflecting the nature of the medium. Graphic "primitives," the building blocks for drawing on computer, are archetypal, or the original forms from which all drawings on the computer screen are derived: simple arcs, circles, lines, and rectangles.

In a poem by Robert Browning, Andrea del Sarto raves about his girlfriend—"a serpentining beauty, rounds upon rounds!" Drawings for *Anima Rising* use predominantly arcs and circles, or "rounds," to capture a sense of the superhuman, feminine principle that existed as an idea even before the universe was "born," the universal masculine principle being abstracted with harder, angular primitives.

The graphics near the beginning of the video can suggest the collective anima's struggle from primordial days before manifestation to more pastoral settings before industrialization. A series of red, pink, and yellow drawings takes the Industrial Revolution as a reference. A subsequent sequence on the war years is followed by a change in the overall tone of the video as more enlightened times approach, times when women can be corporate board chairpersons. The flow of the feminine now accelerates towards full release with ever greater degrees of expression. The final masculine embrace of the feminine in the full light of consciousness marks the full unfolding of people's psychic and spiritual potentials, some time in the future.

The graphics were completed in summer 1984; a recording of the drawings on video was made and the soundtrack developed with assistance from Canada Council's Integrated Media section. Though originally drawn on computer, *Anima Rising* is a videotape for viewing on a VCR.

Silent imagery from the video was exhibited across Canada in 1982 and 1983 in the electronic database magazine *Beta* during Bell Telephone tests to see if people wanted computer data services in homes and offices. By means of interactive phone links via the Anik B satellite, segments were shown in schools and public libraries throughout Ontario during TVOntario's trials of remote-learning systems in 1984 and 1985.

Traditional artistic media offer surface qualities: the play of light on paint or on sculptural surfaces. The computer medium involves the play of luminous light behind glass screens. Screen-based art is experienced by some people as less sensual and somehow detached. Working with interactive databases I often used humour and visual punchlines to keep viewers involved. The *Anima Rising* video is satisfying on many levels, however, and the experience quite intense because *Anima Rising* is a synergy of graphics and sound. The emotive mix of drawings and sound achieves much more than pictures can alone.

The image selected for this book is the beginning of the penultimate frame of a series of over seventy computer frames captured on the videotape, designated "Figurative Culmination." When selected on a public database the computer frame takes thirty seconds to evolve completely on the screen.

Toronto, Ontario

Anima Rising (1984)
Videotape of colour videotex computer graphics, 26 minutes, stereo soundtrack
Musicians: Barry Prophet, Paul Shilton, and Kirk Elliott
Distributed by V/tape and IEPCO, Toronto
Photograph courtesy of Tom Moore, Toronto

William Perehudoff

b. 1919, Langham, Saskatchewan

I had used a brush for this work (I don't usually) and the
painting came off with an interesting kind of fluidity,
something that I hadn't got in many other works. As far
as I'm concerned, it just happened. I paint all the time
and I don't intentionally set out to make changes. Some-
times they just happen. That's what happened here.

<div align="center">Saskatoon, Saskatchewan</div>

AC-86–24 (1986)
Acrylic on canvas
142.2 × 294.6 cm
The artist, Saskatoon
Photograph courtesy of Waddington & Shiell Galleries Ltd.;
Tom Moore, Toronto

Christopher Pratt

b. 1935, St. John's, Newfoundland

Woman at a Dresser has a sentimental value for me. It's
the first painting I did after I came to Mount Carmel; it
was the first figure painting I did in a post–art school
sense. It was the first time I had worked with a model
other than in the art school environment. So there was
all that excitement accompanying it. Then, there was
the fact that it was in the Biennial Exhibition at the
National Gallery of Canada and so on. So there's a senti-
mental attachment that goes with it from all those
points of view, and first moving to St. Mary's Bay and so
on and so on.

It started out to be my wife Mary. The first drawings
I did and the first idea for the painting was Mary, but
then Mary found herself in the family way, as we used to
say. In the latter stages of the painting, a friend of ours
from St. John's, Doreen Ayre, posed for it. But it's not
anyone specific anyway. Both of those two phenomenal
ladies were, as it were, stand-ins for a mental prototype.

St. Mary's Bay, Newfoundland

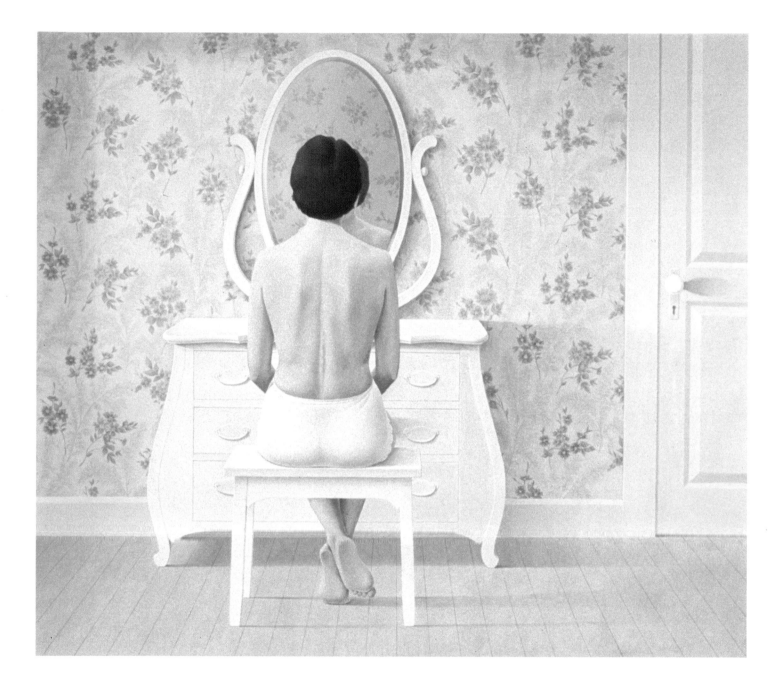

Woman at a Dresser (1964)
Oil on board
66.0 × 76.2 cm
C.I.L. Art Collection, Toronto
Photograph courtesy of C.I.L. Inc., Toronto

Mary Pratt

b. 1935, Fredericton, New Brunswick

This is Katherine—having her first bath. Already she has enough confidence in her mother to take the supporting arm for granted and try to focus her eyes on the drops of water flying from her kicking feet. She tries to gather to herself the world outside her. Her hands are still so new that they're curled; her head is still strangely large for her body; but the basic nature of humanity is already in order. She questions, "What is this stuff? What are those shining specks?"

I didn't expect to see this when I agreed to assist with the ritual first bath. I expected to find my first grandchild amusing, endearing. Instead, I found her intelligent. Not the placid cherub of Renaissance Nativities, but a small person already launched, already asking, "Why, what, where?"

One's children are the joy of flesh to flesh. Perhaps one's grandchildren are the excitement of intellect to intellect.

St. Mary's Bay, Newfoundland

A Child With Two Adults (1983)
Oil on gessoed panel
54.6 × 54.6 cm
Private collection, Colorado
Photograph courtesy of Mira Godard Gallery, Toronto

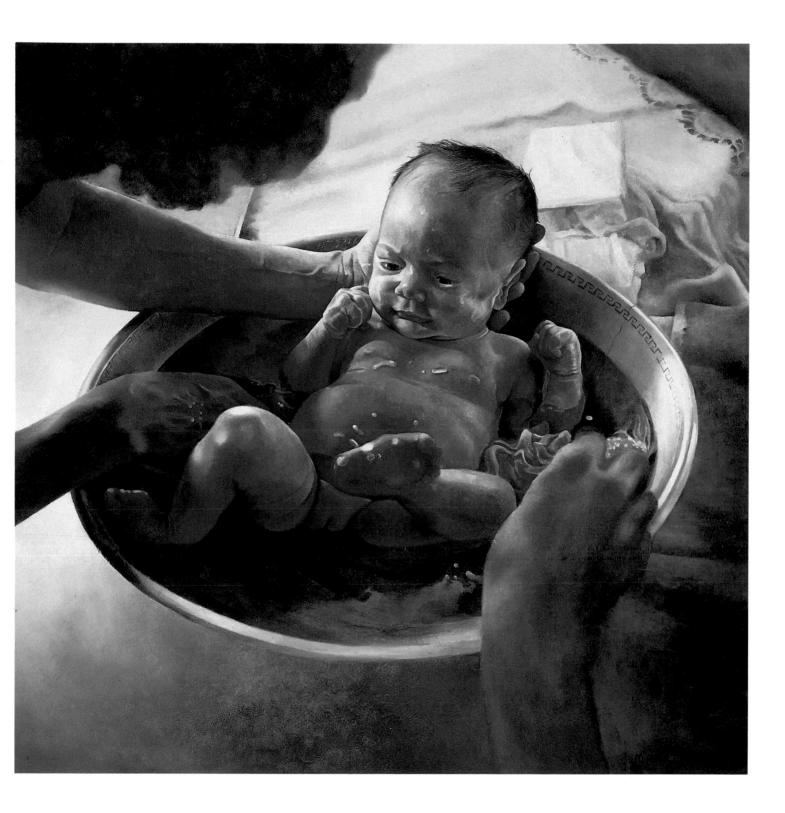

Don Proch

b. 1944, Hamilton, Ontario

The vision of *Blue Canoe Mask* was a fusion of two varied experiences, one very physical, the second intensely emotional. The physical experience was one of prospecting by canoe during three summers in the Canadian Shield of Northwestern Ontario. The untamed landscape, with its challenges to those who venture through it, left an indelible impression on my thinking.

The emotional part of this vision was the funeral ceremony of my schoolmate and friend Jackson Beardy (1944–84). He was a painter who stood in two worlds: one foot firmly rooted in his Cree heritage, one foot in the white man's world. For five years he had his studio one floor above mine, and at times he discussed his situation with me. The evening of his funeral ceremony, I completed three detailed drawings of *Blue Canoe Mask*. I began the construction of this piece the following morning.

This three-dimensional drawing is constructed of a fibreglass shell on a welded steel frame. Suspended from the opening of the inverted canoe and the bottom of the mask are hundreds of chicken bones (each being the same long narrow bone from a chicken wing). The surface of the mask is toned with sterling silver wire, graphite pencil, and coloured pencil.

Winnipeg, Manitoba

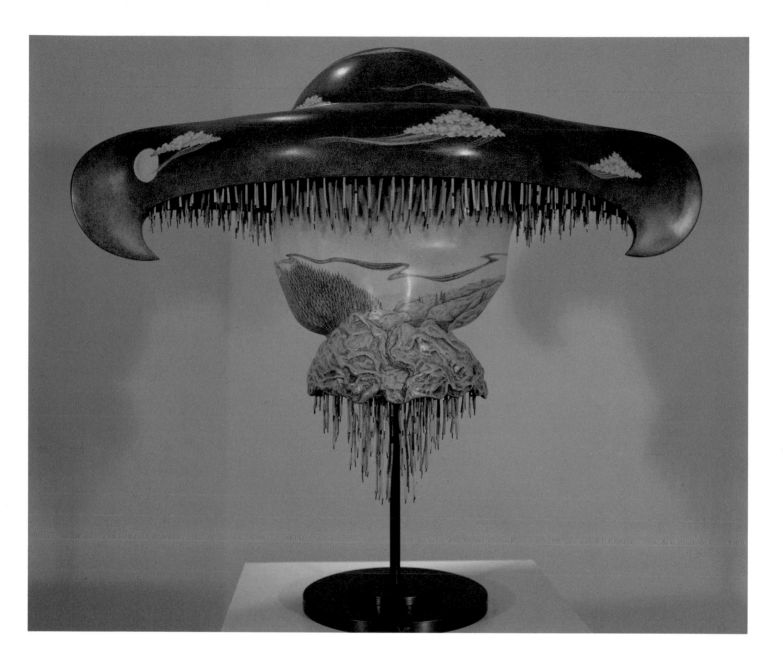

Blue Canoe Mask (1985)
Silverpoint, graphite pencil, and coloured pencil on a welded
steel, fibreglass, and chicken-bone construction
91.5 × 40.6 × 81.3 cm
Private collection, New York
Photograph courtesy of Woltjen/Udell Gallery, Edmonton

Gordon Rayner

b. 1935, Toronto, Ontario

'Twould be vain
To choose a favourite
Then savour it.
'Twould be insane
Unfair to the viewer
To throw the rest in the sewer
To pick a best and throw down the rest?...
But I digress.

The latest
Is never the greatest!
Else I'd stop
Plop.

Nevertheless,
Always the more.
This one will do
Because, what came before
Was then an end.

And
I cast no aspersion
T'ward my time in Persia.
(Even though I ran from Iran.)

The Rug
Was my bug
As it loomed before me,
Damn near doomed me.
The Tehran cops arrested me
But 'twas the carpets
That bested me
And this art came
Out of art once again.

Carpet before the pony
Only the lonely
Woof and warp
Zooming quarks.

This painting hangs in Budapest
I suspesht.

Toronto, Ontario

Persian Persuasion (1978)
Acrylic on canvas
183.0 × 213.4 cm
External Affairs Canada, Budapest
Photograph courtesy of External Affairs Canada, Budapest

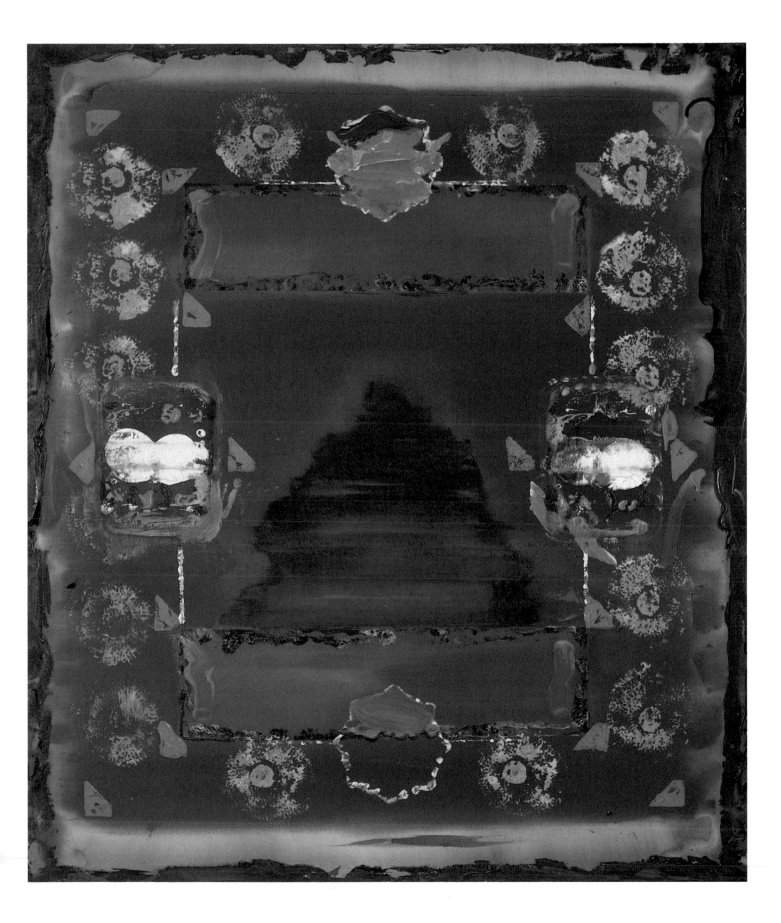

Alan Reynolds

b. 1947, Edmonton, Alberta

Stand's Coat is a piece of sculpture, made in 1986, that is part of a series of work begun in 1985. These upright pieces with narrow bottoms are the most complete of any previous series of work of mine. Picking any one work as the best is something I must leave to the critics. I personally cannot afford to judge an individual work in this manner. Every sculpture, successful or not, has qualities that may be important to me and in the case of unsuccessful pieces, more often than not, elements will find their way into another work.

Each piece of sculpture in a series of work is a reflection of a previous work's alternative directions suggested during its making. Every sculpture, at some point just before it comes alive, offers a few different ways to proceed. In *Stand's Coat* the piece is more simple in its elements than the previous one. The complex play of small structural elements is assured by the paint handling.

The purpose of painting is not only to seal and protect the steel but to take colour and make it as important a sculptural element as, say, line or mass. In the case of *Stand's Coat*, I feel the end has been met successfully. In other works in this series, smaller steel elements provide the visual detail necessary to bring to life the piece of art. For these sculptures the paint handling will create a more simple colour surface so the strength of the parts will not be diluted with an abundance of colours.

Inspired by Oriental art (Indian, Chinese, and Cambodian sculpture), these works are my most complete and mature to date. Their scale, one-half to three-quarters human size, reflects my need to make art that is personally satisfying but that will also bring me closer to an understanding of my part in reality.

Edmonton, Alberta

Stand's Coat (1986)
Painted steel
157.5 × 45.7 × 45.7 cm
The artist, Edmonton
Photograph courtesy of William McKeown, Edmonton

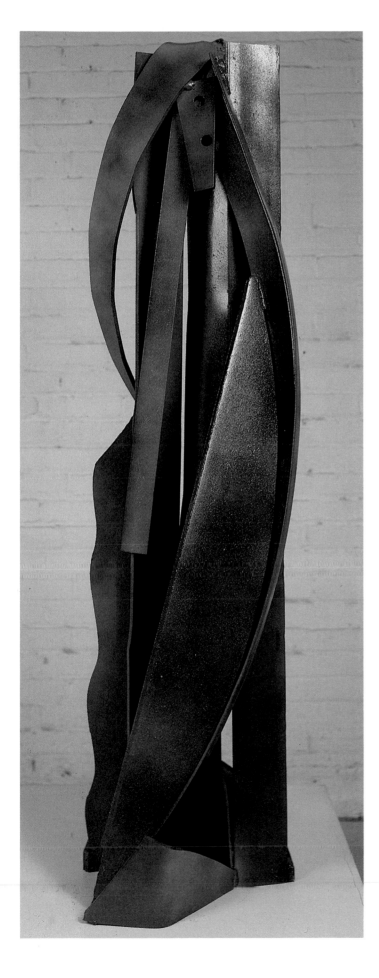 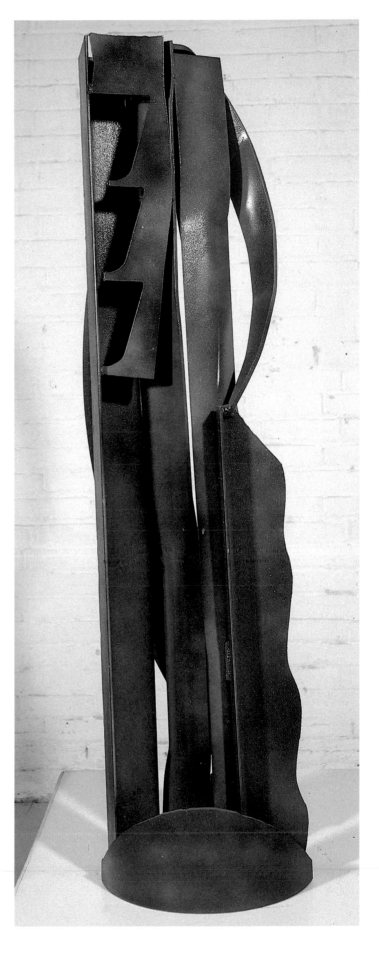

145

Jean-Paul Riopelle

b. 1923, Montreal, Quebec

I painted this in Paris, where I had gone after the *Refus Global* was published in Montreal. It is one of those special paintings—I worked on it for two years. I had extreme difficulties in getting the support material. *Grande Composition* is oil paint on pavatex, the French word for a material which preceded masonite. I have not done much on this material. Only one firm made this size. I had only a few boards like this. You can't get them today. I only did two works on this material—the other one is in the Museum of Modern Art in New York.

This painting was done before the word *psychedelic* became a concept in society. I painted such works before anybody knew the word.

The painting evokes a response similar to the moving experience one feels when one visits Chartres in France and admires the stained glass windows.

Ste.-Marguerite, Quebec

146

Grande Composition (1949–51)
Oil on pavatex board
170.5 × 261.0 cm
Mr. & Mrs. S. Lallouz, Montreal
Photograph courtesy of Galerie Samuel Lallouz, Montreal

Otto Rogers

b. 1935, Kerrobert, Saskatchewan

El Greco Fervor is characteristic of much of my work. The painting is created by juxtaposing qualities seen and experienced in nature with geometric elements arranged for structural beauty. Neither landscape nor abstract form is the desired aim: what is sought is a visual representation of a human condition. Motion and stillness are key players in this aesthetic drama, which stands as a sign for man's struggle in this life. What my work strives for is an inner peace contained and fostered by means of an ordered form. This requires spirit and mind.

In a recent letter, *The Promise of World Peace*, written to the people of the world by the Universal House of Justice, the supreme governing body of the Baha'í Faith, we find the following passage, which I feel explains my own struggle as an artist: "The endowments which distinguish the human race from all other forms of life are summed up in what is known as the human spirit; the mind is its essential quality. These endowments have enabled humanity to build civilizations and to prosper materially. But such accomplishments alone have never satisfied the human spirit, whose mysterious nature inclines it towards transcendence, towards the ultimate reality, that unknowable essence of essences called God."

The desire for transcendence creates in my artistic struggle discontent with a minimum response, with ordering known arrangements. I am led to a juxtaposition of diverse elements which one might not expect to be together, such as the static opaque geometric blocks and the moving transparent space of the sky. These diverse elements are held together in one drama which aspires to a unity through diversity. I experience a similar fervor in the great painter El Greco and therefore named this as a tribute to his work.

Saskatoon, Saskatchewan

El Greco Fervor (1986)
Acrylic on canvas
152.4 × 152.4 cm
Private collection, Toronto
Photograph courtesy of Mira Godard Gallery, Toronto

William Ronald

b. 1926, Stratford, Ontario

This work is part of my Prime Minister series. There are many good portraits in it, like the one I did of Mackenzie King, which is figurative. My Pierre Elliott Trudeau is important partly because of him, the man, and partly because of the response the painting has had with the public. I have toured coast-to-coast with this painting and in most of the cities it had an enormous response.

I worked four to five years before I got what I wanted. I have liked and known Trudeau since 1969. This was my third attempt at him. My first portrait was too papal, too precious. It was seventeen feet wide by six feet high. My second version was too floral. It was twenty feet long by eight feet high. It conveyed only the 1960s for Trudeau. My present version is ten feet high. Trudeau *is* bigger than life. To condense him is difficult. The background in the work represents Trudeau's Jesuit upbringing. The two halves of the canvas show his two sides—one of them is warmer. I used the Maltese cross in the background to show his Catholicism. His halo-like cross is slipping a bit.

Basically, the picture is a head with black and grey in the brain area to represent his enigmatic qualities. In the lower part of the head there is a construction drawing of a female nude and I placed an important part of the female anatomy at the point of his necktie. I showed him that and he said, "I don't mind that at all."

When I am dead, the Prime Minister series is one of the things Canadians will remember me by.

Toronto, Ontario

Pierre Elliott Trudeau (1982–83)
Oil on canvas
304.8 × 182.8 cm
The artist, Toronto
Photograph courtesy of Jim Chambers, Toronto

Henry Saxe

b. 1937, Montreal, Quebec

For the past decade or so I have been preoccupied with an imaginary model of space which includes motion, memory, and time. A metaphor of this would be a planar spinning disc with a centrally located perpendicular axis as long as the disc's diameter. The model can be even more closely approximated if the spinning disc assembly is seen wobbling, as though to a stop, across a table travelling in any position through space.

Traineau is a literal model of my imaginary model. Done in 1985, it marks a midway point between the half-inch steel plate sculptures I was doing in the 1970s and early 1980s and my more recent work in aluminum.

Tamworth, Ontario

Traineau (sled) (1985)
Steel, aluminum, concrete, oak
365.8 × 487.7 × 213.4 cm
The artist, Tamworth
Photograph courtesy of the artist, Tamworth

Jack Shadbolt

b. 1909, Shoeburyness, England

I have had a complex, on-going relationship with West Coast Indian art since I was a young art student in 1926. From the beginning I was aware of Emily Carr's presence in Victoria and I met her about four years later and saw at first hand in her studio her great Indian Village paintings. In fact, my own first drawings were from the Indian masks and totems in the Victoria museum. Their capacity to enter a spirit world appealed to my theatrical imagination but I was also aware of their powerful command of design.

Later, as I developed and travelled and visited museums like the Musée de l'Homme in Paris, I was drawn inevitably to the primitive arts like the African and New Guineau. The nature of the fetish idea haunted me. I was soon aware of how primitive art cast a net of abstract design over the objects of the spirit world it feared and thus brought them under control. The viewer has to work through the decorative surface to reach the trauma of dread beneath.

As my own art matured and I was driven by historical and personal necessity to come to grips with abstraction, I found that my natural designing instinct for decoration could be harnessed to the deeper drama I was striving for. I found that neither the stylized nor the non-objective forms of abstraction were compelling enough to rid me of my own psychological tensions. I turned more toward Picasso and the primitives, to find my abstract solution by the dismembering and re-assembling of parts of the organic world which could be stated in strongly designed, enigmatic equations, abstract yet evocative.

When I decided to return to the West Coast to live, I again found the Indian art process a great sustainer. Their notion of an emblematic display of the form showing simultaneously both the outside shape and the inside structure provided the last link in the chain of manoeuvres that freed my imaginative invention.

Having completely familiarized myself with the Indian forms, I would often re-invent spirit presences of my own from various pieces of borrowed parts, improvising my own connective principle of abstraction and trying to build new images of equal but different expressive power. These works were a phase of my self-education, in the way Picasso's crucial *Demoiselles d'Avignon* digested his relation to African art.

For me, *Guardian* is a work from that period, where the fusion was successful.

North Burnaby, British Columbia

Guardian (1972)
Acrylic on watercolour paper
152.4 × 101.6 cm
Private collection, Vancouver
Photograph courtesy of the artist, Vancouver

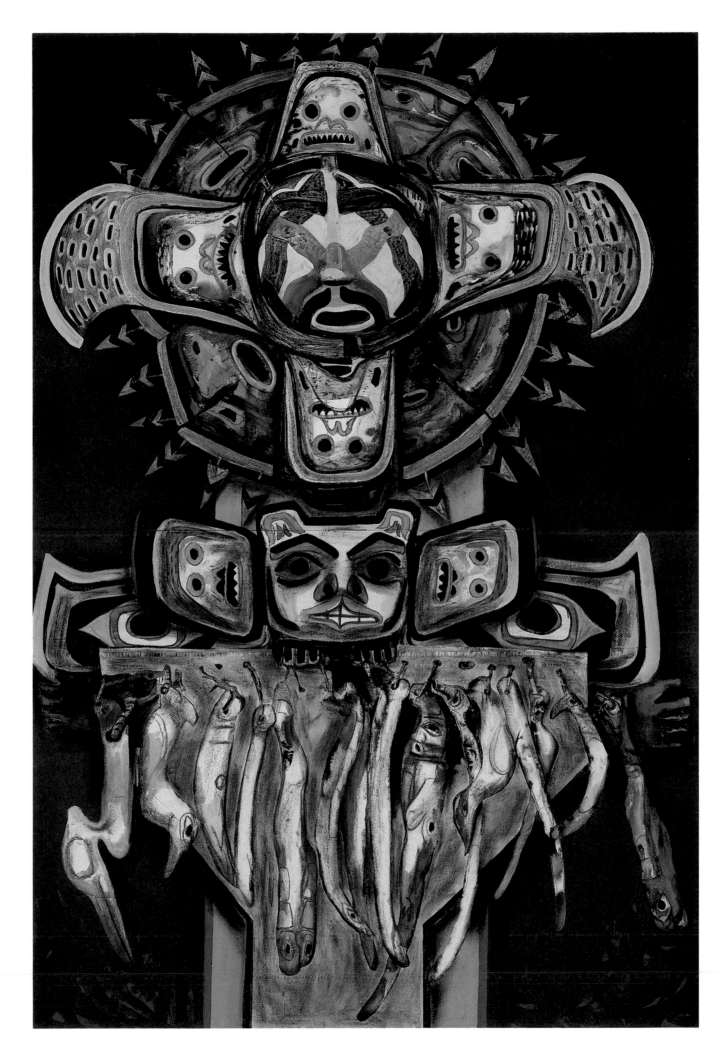

155

Ron Shuebrook

b. 1943, Fort Monroe, Virginia

My paintings respect the legacy of early twentieth-century modernism, with particular attention to Cézanne, Matisse, Mondrian, and, perhaps, more indirectly to Malevich. It was the example of the New York School with Robert Motherwell, Clyfford Still, Barnett Newman, and Mark Rothko that initially convinced me that abstract painting could declare its intense seriousness. Hans Hofmann's teachings and paintings taught me that conscious analysis and intuitive response were not necessarily at odds. Franz Kline and Willem DeKooning demonstrated the possibility of gestural relationships structured precisely. Other artists have proven to me that painting remains a viable way to embody a seemingly infinite number of subjects. I pay attention to individual works, but allow that there are numerous points of view.

The *Untitled* painting from 1985 reproduced here is a pivotal work for me because it suggests a direction that unifies the facts of the painting process: the explicit, deliberate structure; the drawn, evocative shape; the spatial capacities of colour. This allusive painting declares its origins in careful thought and remembered feelings. It acknowledges its material evidence but transports the viewer beyond the literal; it is confident yet anxious. In short, it satisfies me as an object that is resonant with my sense of the world. To be sure, this painting remains but a glimpse of the possible, but it is an intriguing, authentic option.

As I have looked at this painting during the past year, in my studio and in my exhibition at the Concordia Art Gallery in Montreal in March–April 1986, it has given me experiences that I had not consciously built into the work. I thought of dusk in the English countryside, of shadowed hedgerows, of walled darkness. I considered the fact of the rectangle; the relationship of my body to the canvas; the act of painting; the stained surface; then, the translucent impasto; the physical manipulation of the resistant yet amorphous material. The painting exists as accrued decisions, pragmatic acts, and ongoing experience. It is lodged in history, both personal and the larger sweep of forces beyond my own.

I now see this painting in its present mystery. It seems to be both place and object. It is logical, though psychologically charged; firm yet redolent with spatial movement. I know that it stands for continuity, that it extends tradition. On the other hand, it resists simple naming. I did not anticipate its final form; I don't quite understand its persuasive order. It has urged me on despite my doubt. Perhaps, more than any of my previous work, this painting achieves a quality of immateriality through material means.

Halifax, Nova Scotia

Untitled (1985)
Acrylic on canvas
213.4 × 152.4 cm
Art Gallery of Peterborough, Peterborough
Photograph courtesy of the Olga Korper Gallery, Toronto;
Tom Moore, Toronto

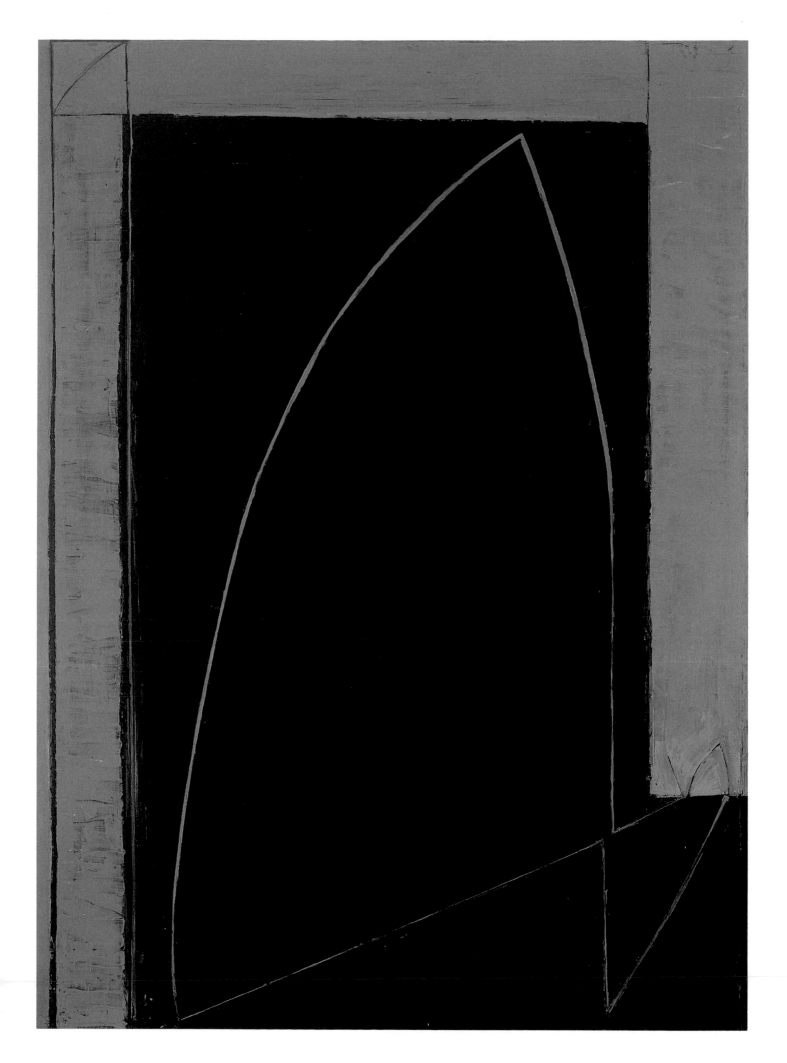

Paul Sloggett

b. 1950, Campbellford, Ontario

Because I have it in my own collection, I see this picture every day, and I'm still learning from it. It has retained its mystery for me and has provided me with ideas for many other paintings.

Between the Jockos was originally based on a Matisse painting called *Head of Blue and Rose* (1918), not the typical organic quintessential Matisse but a rare strong geometric one that appealed to my sensibilities. There are a number of juxtaposed contrasting elements in my painting that make it visually resonant. There is a tendency to view the shape illusionistically as a kind of box in space yet the illusion is held back by surface relief sculptural elements that stress their attachment to the surface. There's a confidence in the colour, shape, and composition that I believe makes this one of my strongest paintings.

Pickering, Ontario

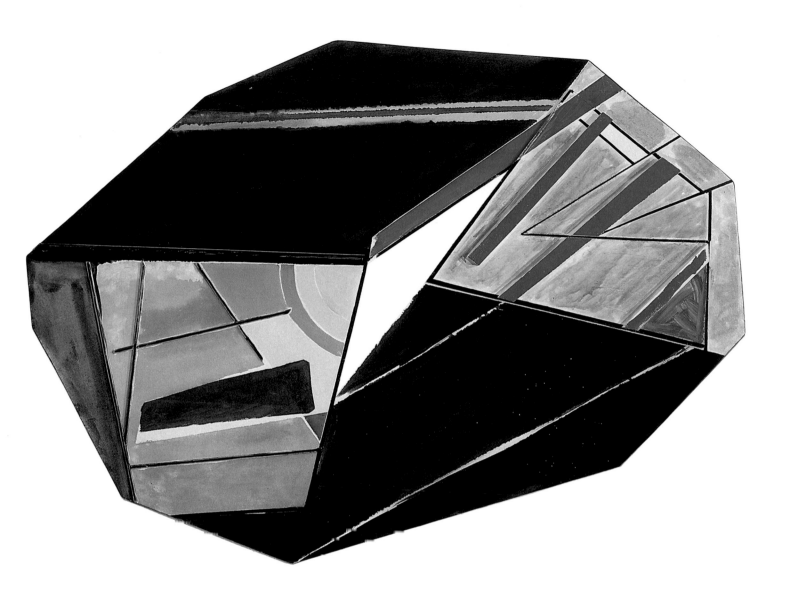

Between the Jockos (1982)
Acrylic, wood on canvas on plywood
129.5 × 179.0 cm
The artist, Pickering
Photograph courtesy of Tom Moore, Toronto

Michael Snow

b. 1929, Toronto, Ontario

When I was asked by Joan Murray to choose a work that I consider the "best" I've ever done, I was pleased to be asked but stymied: to choose the "best" is impossible. There are many reasons, apart from the slight to the rest of one's life's work. Retrospectively I might consider a work to have been especially successful (or unsuccessful!) but I work and have worked in many media: drawing, printmaking, painting, sculpture, photography, holography, film, music; and I have also published three books. Not only is there little or no basis for trying to choose between a "successful" ("best"?) book and a huge steel sculpture, there's almost as little basis for trying to choose only within any one medium ("best" film, "best" music, "best" drawing). Each of the films I've done, for example, has a particularity, a specificity; some are short (3 minutes) but good, others long (4½ hours) and also good.

Within each of the media in which I've worked, I could probably name a number of works I consider among my "best." In film: *New York Eye and Ear Control*, *Wavelength*, *Back and Forth*, *One Second in Montreal*, *La Region Centrale*, *Rameau's Nephew*, *Presents*, *So Is This*. Sculpture: *Blind*, *Scope*, *View*, *Portrait*, *Seated Sculpture*, *Core*, *Transformer*, *Monocular Abyss*, *Flight Stop*. Music: *Michael Snow Musics*... on the Chatham Square label, which I designed, *The Artists Jazz Band*, and *Volumes 1 to 5* by the CCMC, the group I've been playing with since 1974. Photographic works: *4 to 5*, *Authorization*, *Press*, *A Wooden Look*, *Field*, *Glares*, *Midnight Blue*, *Light Blues*, *Imposition*, *Multiplication Table*, *Traces*, *Waiting Room*, *Plus Tard*, *Door*, *Times*, *Iris-Iris* are works I'm proud of. Some works (some "good" or "best" works) are hard to categorize; I like *A Casing Shelved* slide and sound tape, *Sink* carousel slide work, and *Quintet*, a photo and painting work. There is a series of folded paper works: *Paperape*, *Stowaway*, and there's *De La*, a video installation work with a moving metal sculpture and video camera, as well as *Hearing Aid*, a sound installation. Among the holographic or holographic/sculptural work: *Still Life in 8 Calls*, *Redifice*, *Egg*, *Sailboat*, *Steamer Trunk*. Painting: Many still seem "successful", but I'd single out *Seated Figure*, *Lac Clair*, *The Drum Book*, *Green in Green*, *Theory of Love*, *Secret Shout*, *Mixed Feelings*, *Spring Sign*, *Beach-hcaeB*, *Clothed Woman*, *Interior*, *Stairs*, *Switch*, *Hawaii*, and *Venus Simultaneous*.

So why did I decide on a photograph of *Venus Simultaneous* to be reproduced here?

In the first place, I decided that painting would be the most suitable medium to be reproduced in a book. A still from a film can give as little sense of the work as a photograph of a piece of sculpture. Holography is very difficult to photograph, music obviously impossible. Most of the gallery work I've done since 1967 has been photographic, but I decided against any of these works for reproduction in a book partly because of the deceptions involved in photographs of photographs; the size of the original, in my case, is important.

One aspect that makes *Venus Simultaneous* a reasonable choice for reproduction is precisely that it is concerned with "reproduction." Also, it copes well with the inevitable reduction of image size: *Venus Simultaneous* has a legible measurement in it—the abstracted, cut-out figure is "life-size," five feet tall.

Between 1961 and 1967 all my work utilized the same outline of a figure: The Walking Woman. There were hundreds of works in many media and materials. *Venus Simultaneous* is one of the biggest and "best" of the series. It is a painting/collage, the colour is very interesting, it has a sculptural or "relief" aspect. It involves sequence, process, and time—elements perhaps more clearly utilized in my films (and some photographic works) and music, but *Venus Simultaneous* is a "successful," "plastic" use of time.

A photograph of a work of art will not substitute for an experience of the real thing. *Venus Simultaneous* is in the collection of the Art Gallery of Ontario and frequently available for public viewing. I hope you will see it.

Toronto, Ontario

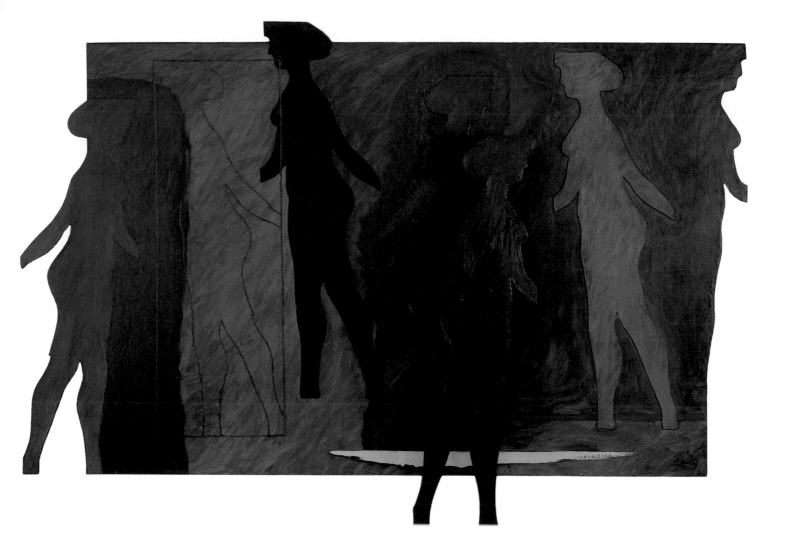

Venus Simultaneous (1962)
Oil on canvas and wood
200.7 × 299.7 cm
Art Gallery of Ontario, Toronto
Photograph courtesy of Carlo Catenazzi, Art Gallery of
Ontario, Toronto

Michael Sowdon

b. 1949, Yorkton, Saskatchewan

No Jesus represents an aesthetic and technical turning point in my work. Holography's constraints have influenced the art created with this technology. Much of holography is more techno-craft than fine art. The imagery is usually contrived and often lacks real human content. My own early work was often almost totally concerned with finding a suitable object to record and then trying to get the technology to work. This approach became unsatisfactory, so I began integrating more of my concerns in life into the work.

At the start of the 1980s, I became fascinated by the phenomenon of born-again Christian television evangelism. I often could not believe what I was watching. It is absolutely awful entertainment and would be completely laughable if not for the fact that these people seem to be gaining real political power in the U.S.A.

One day in 1982, I was sketching at my desk when it suddenly dawned on me that secular humanists needed something like the universal symbol prohibiting smoking to designate religion-free zones for people not interested in Armageddon, sin, guilt, or giving all their money to some preacher from North Carolina. I applied to the Artist-in-Residence Program at the Museum of Holography in New York City to make *No Jesus* because at that time there was no facility in Canada with the capability of producing multi-colour holograms.

No Jesus was technically challenging. Precise colour control and registration were necessary. The Technical Director of the museum's laboratory, Edward Bush, and I worked for a month on the recording of the three master holograms required to produce the separate colours and elements that compose the image. The final printing of the information contained in each master hologram onto the copy plate was especially complex.

This has proven to be controversial. Since I started to exhibit *No Jesus*, it has delighted some people and offended others. I have even been accused of being the Anti-Christ. Total strangers have told me they were praying for my redemption.

Toronto, Ontario

No Jesus—for the Moral Majority (1982)
Three-colour transmission hologram
Photo emulsion on glass plate
30.0 × 40.0 cm
Production: Dennis Gabor Holographic Laboratory,
Museum of Holography, New York City, N.Y.
Technical Director: Edward Bush
Photograph courtesy of the artist, Toronto

Lisa Steele

b. 1947, Kansas City, Missouri

I began production on *The Gloria Tapes* in 1979. In its finished form, this tape is in four sections. It features a central character, Gloria (played by myself), who is a young, single mother on welfare. The tape chronicles Gloria's interactions with various social agencies, with her immediate family, and finally with the justice system. The tape succeeds, I think, because "it's funny and it's not stupid" (to quote, out of context, a Toronto video viewer).

I conceived of this work as a soap opera with a socialist-feminist bias. I've had the good fortune to exhibit and present this tape in a wide variety of settings and to discuss it with a broad range of people. The response to *Gloria* has invariably been one of engagement. Most people viewing this tape understand the issues I am talking about (whether or not they agree with my position) and are willing to watch the tape for its duration.

The central character in *Gloria* is a composite, created as a result of my experiences as a worker at a shelter for battered women (Interval House, Toronto, where I worked from 1974 to 1986). I wanted to understand some of the young mothers with whom I was working at that time. With *Gloria* I began to see that I was mapping my own experiences and expectations onto their lives. I realized that a number of these young women, in my terms "hopeless" when I first met them, had begun to take control of their lives in ways that I would not have predicted. I began to see that I could not "measure" their progress or success against popular notions of "successful women." I wanted to write a script that would reproduce my own experience of a gradual, step-by-step understanding of the way many women were living their lives. I tried to present the story in such a way as to allow an audience to change its opinion of how "successful" Gloria was at coping with her life.

When Gloria first appears, she seems stunned, disconnected from "the real world." But somewhere in the middle of the tape she begins to change. When she confronts head-on (something her aspiring middle-class sister cannot do) her own painful childhood experience of an incestuous father, she begins to take control. The change is minute in dramatic terms, but significant nonetheless.

Gloria was produced in soap-opera format, my intention being to feature characters of a different economic class from those usually presented on TV. During one conversation at Interval House about TV, the women came to agree that one of the problems with the soaps was economic misrepresentation. As one woman said, "I like the stories and a lot of times I can really identify with what the people are feeling—but they're all so rich."

As an artist using video—whether or not my work is ever broadcast, it still plays most frequently on a television set—I see the strength of using formats derived from television, in order to communicate with an audience because of the shared experience that television has given us. But being an artist, I also challenge these formats—not just by incorporating different content, but also by "skewing" the formula. In the case of *Gloria*, I produced a tape that has the feel of a soap, but is anti-soap opera in its construction and presentation.

In *Gloria* the audience sees the central character *reflect* on deeply emotional experiences, rather than seeing the experiences themselves. I did this to create a distance between the viewer and the content of the tape. This breathing room permits the viewer to identify with a character who might otherwise be viewed as simply an isolated individual or a "social outcast." By the incorporation of internal monologues and one-sided dialogues in the tape, viewers have the opportunity to see something of themselves in Gloria. I am not claiming Everywoman status for Gloria. Nor would I claim that most viewers have said "Hey, that's me up there." Instead, something much more subtle happens. Sometimes, viewers experience a very slight movement—just like Gloria, a single mum on welfare, an incest survivor.

Toronto, Ontario

Social worker (Jenny Roberts) to Gloria: "It's too bad the baby's asleep, Gloria, but there are some things that can be done just as easily without her. I've brought along a training doll. Now, first we'll do cleaning the baby's bum after she's had a bowel movement."

The doctor (Blanche Polk) to Gloria: "I've brought some young doctors, Gloria, just to have a little peek. I hope you don't mind." To the interns: "What we have here is a primary and a secondary lesion of the fallopian tube..."

The doctor continues, "We'll be going in through the navel—right through your belly button, Gloria—[returns to young doctors] we'll be making the decision in the O.R. as to how to proceed. We just want to get in there and get this mess sorted out. Right, Gloria?"

Gloria finally gets to ask the doctor her question: "Somebody told me I should be cleaning my baby's ears with a Q-tip. Do you think that's right?" The doctor: "Don't worry, Gloria, don't worry about that right now." But Gloria does worry: "I don't think that's right. I'm afraid I might hurt her."

The Gloria Tapes (1979–80)
Video tape, 54 minutes, colour
Distributed by V/Tape, Toronto
Photograph courtesy of V/Tape, Toronto

Gabor Szilasi

b. 1928, Budapest, Hungary

Around the mid-1970s, after twenty years of having photographed in black and white, colour was a new departure for me. Up to then I had done colour commercially but I never considered it a creative tool. I found it "too real," almost vulgar. I found some of the informational value in colour interesting, but it rarely surprised me: I always knew that the sky is blue or earth is brown. The abstraction, the ambiguity of black and white satisfied me.

Then I realized that colour may become important and even indispensable when describing certain cultural and social characteristics. As an extension of my previous interests I started photographing interiors, mostly living spaces, in colour. I was fascinated by the way colour revealed personal tastes. I was not interested in colour composition as such. I let the colours speak for themselves—the way the person selected them and arranged them. A few years later I combined my two main interests, portraits and interiors, by taking a black-and-white portrait of a person along with a colour photograph of his or her living space and putting the two images in the same frame. The two complemented each other. They created tensions.

Around 1982 I started photographing electric signs, as an extension of my interest in the urban environment. What interests me is the way these lit-up signs (neon or other) are integrated in the architecture. I concentrate on signs that have an artisan quality about them, often combining naive or popular art, even kitsch, with the sophistication of electricity. In addition to the sign itself, the architecture of the building has to have a certain character too. In order to show both I make my photographs around dusk, during those critical ten or fifteen minutes when the light (both natural and artificial) is perfectly balanced.

The photograph I've included is a typical example. It has a flavour which is typically Montreal, which was also important for me at that time. I'm planning to extend this series to other cities and cultures.

Montreal, Quebec

Frites Dorées, Golden Chips (1984)
C-print
35.6 × 27.9 cm
Photograph courtesy of the artist, Montreal

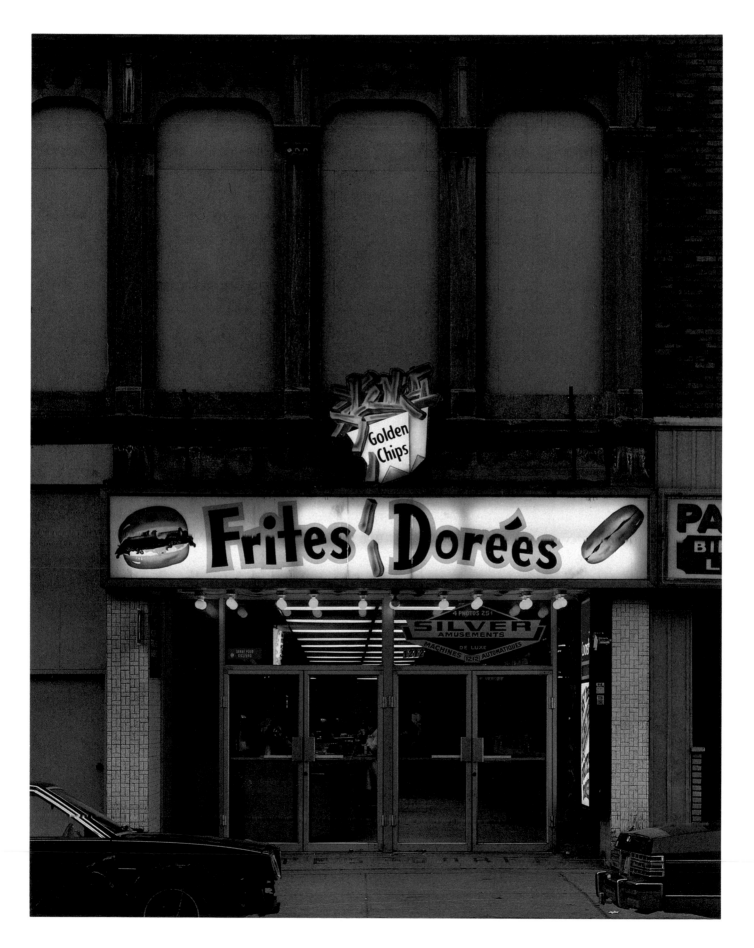

Otis Tamasauskas

b. 1947, Terschenreuth, Germany

I have always based my work on experimentation. Through this experimenting, I believe that I will develop a personal direction and align a set of values and aesthetics. This, therefore, implies that my last print should always be my best.

In this particular work (my most recent), I wanted the image to have an ease of delivery which, at times, is difficult with the medium of print. I was trying to achieve a brooding presence within the image as well as a sense of light and air and colour. I wanted the print to appear as if it had happened at once but was not randomly conceived, as overlays of colour create deep veils and translucent surfaces.

Again, through experimenting, I still allow the print to have its own way. For me, prints are bridges in innumerable directions to unconscious thoughts and self-knowledge. This self-knowledge is deeply anchored in the Jungian concept of a reconciliation between the self and the elements. I find the stone process of print making as basic as fire and water. I like the primordial presence of the actual quarried shapes of the stones with which I work. They have weight and mystical properties that I feed off of. My prints achieve a printerly effect.

These combined properties are unachievable for me in painting. I am more interested in moving my formal concerns to the background while forcing the metaphors, symbols, and unconsciously released visual concepts to the fore.

The three shaped stones in the Poacher Series are used in a triptych manner telling a story that is fragmented yet comes together as a whole.

The poacher image was conjured up through springtime investigations of Glenelg County, Ontario. It is based on observations of blue herons and local fishing habits...a very special concern of mine. I tried to achieve a landscape quality but a landscape which deals with an abstract interpretation.

Kingston, Ontario

Poacher Series, Glenelg: Watching (1986)
Stone lithograph on B.F.K. Rives paper
101.6 × 152.4 cm
2/5
Printed with the assistance of Geoffrey Levy
The artist, Kingston
Photograph courtesy of Carl Heywood, Kingston

David Thauberger

b. 1948, Holdfast, Saskatchewan

It's a painting of the site in South America. It has all the things I like in my paintings: it's big, it has lots of colour, and physically it has all that nice tactile stuff going on with it. The way the image presents itself to me is also special.

Another reason I chose this painting was that it came at a time when I was having difficulty with getting painting done at all. This was the one large painting I completed in the almost two years that I was employed by the Saskatchewan Arts Board. The completed picture gave me confidence to leave that job and get back to painting full-time.

Regina, Saskatchewan

Machu Picchu (1983 or 1984)
Acrylic, glitter on canvas
251.5 × 172.7 cm
Mira Godard Gallery, Toronto
Photograph courtesy of Tom Moore, Toronto

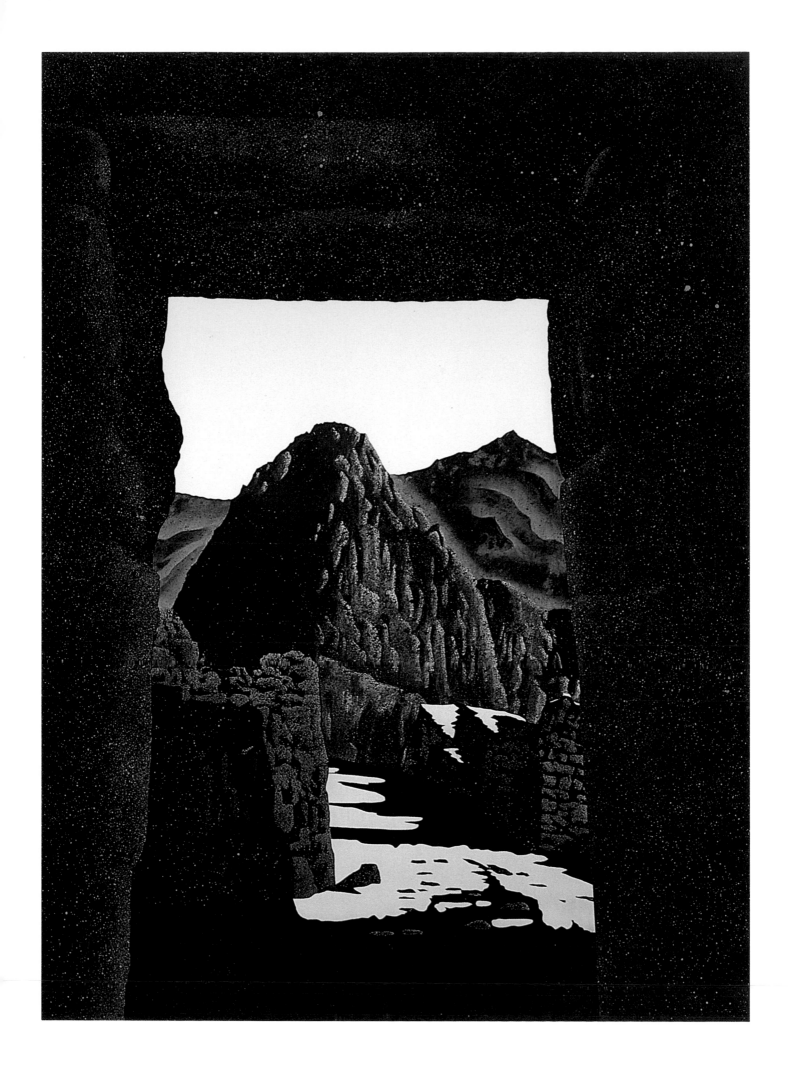

Joanne Tod

b. 1953, Montreal, Quebec

I consider this a successful painting because it consolidates, with an economy of imagery, many of the concerns with which I have dealt in earlier work. *Two Perspectives* addresses specifically the inability to objectify one's own experience. A woman views a painting in an art gallery; in turn she becomes the object of observation. The implicit paradox is that an ostensibly private act (that of looking at art and formulating one's own opinion) takes place within a large and very public context. In the same manner that contemporary culture cannot be adequately analysed without examining history, the implication in this work is that ideas occur as a result of an associative process or, figuratively speaking, are "coloured" by their inescapable interrelationship.

Toronto, Ontario

Two Perspectives (1986)
Oil on canvas
152.4 × 312.4 cm
Private collection, Toronto
Photograph courtesy of Peter MacCallum, Toronto

Claude Tousignant

b. 1932, Montreal, Quebec

There have been several key works in my career—works that have both effectively synthesized what preceded them and foreshadowed what was to follow. Most important among these, though, is the 1956 painting entitled *Monochrome orangé*. This work represents an early intuitive flash concerning a principle that I have since explored—and am still exploring—in some depth. This principle is central to my view of the "painting-as-object," my manipulation of existential rather than aesthetic space, and my perception of my work as being non-anecdotal and non-symbolic.

Montreal, Quebec

Monochrome orangé (1956)
Enamel on canvas
129.5 × 129.5 cm
The artist, Montreal
Photograph courtesy of the Montreal Museum
of Fine Arts, Montreal

Serge Tousignant

b. 1942, Montreal, Quebec

I've made photography my medium since 1972. It gives me the opportunity and the possibility of having images that are at one and the same time graphic, sculptural, spatial, painterly; it's fiction with the greatest amount of reality.

The first series of my *Géométrisations Solare* was made in 1979, my second series in 1980. In the beginning I played around with twigs, sticks, and shadows. I put photographs one beside the other in a grid pattern or in a suite pattern so that one would be confronted with two readings and see, perhaps, what was inside the photograph. The shadows made triangles, squares, lozenges. In my second series, *De Sans Solaire*, I used the same technique but the photographs were made to be seen individually. The approach was more complicated. I'd get a square in a square, a lozenge in a square, a triangle in a square. The structure is more irregular but it creates shadows that are regular and two or three types of shadows within one shadow.

My sun drawings made art with natural elements—different types of sandy grounds, beaches, sticks that I would find on the premises, the sun or its absence. The shadows give the drawings the pattern. My pieces were made totally from the environment but the content was rational. I always try to avoid artificial elements. At the same time I have a divided approach: I'm spontaneous, but afterwards I reflect on the idea.

When you look at the image, notice the perceptual ambiguity. You think it's flat and that it's like sticks and that shadows were drawn on the paper. But when you come close, you realize that it's only by looking at things that you get a point of view.

Montreal, Quebec

Sun Drawing #25 (1980)
Colour photograph, R.C. paper
40.6 × 50.8 cm
Photograph courtesy of the artist, Montreal

Harold Town

b. 1924, Toronto, Ontario

Picasso, when asked "Who was the greatest painter that ever lived," replied "On what day?", a brilliant remark that covers individual paintings as well as painters. What day, what year, what period, what medium, under what conditions—there cannot be a clear-cut best in any artist's work.

Made up of corallitic accretions and painful increments, lit on rare occasions by bolts of revelation, and then stuffed behind the wainscoting to grope in the mouse-turd dust, art is the equivalent of Athlete's Foot, at best an exquisite itch, at worst an excuse to stop walking. On the emotional side, it is either masturbation with a hockey glove or a night beneath the sliding moon that shames Eros.

Art has no middle ground. Either it works or it doesn't. Bad art is not the enemy, mediocre art is the enemy. Ironically, the impetus for great art seems to grow from the chasm between failure and aspiration, a prime example being the gritty determination of Cézanne to stick to his chosen path through a lifetime of work that he deemed a failure.

Many explanations by artists of their work are merely retroactive fabrications, structured after the accident that led them to a creative discovery. It is a case of tripping and making a virtue of the rug that causes the fall. Others just appropriate the colour theories of a great pioneer such as Michael Eugene Chevreul, or take a drink from the trough of the latest overnight conformity and spit out an attenuated version. Given the fact that most of the painters I have met have not heard of the Purkinje Shift or eye dominance, I am suspicious of all artist talk and especially my own.

However, in the case of *Actress in Sidelight*, I know exactly what the work means to me, which is of course quite separate from any explanation of what it is.

Though nagged by the thought that I might have been precipitate in leaving figurative painting I had, by midsummer of 1952, been mucking about with abstraction for some time. I was in free fall, excited, and just part of a brush and colour moving on panels which quickly filled the last dinky room I had acquired on the top floor of 64 St. Mary Street, Toronto. The house was stove hot, and empty, the other members of our co-operative space having fled to the country. I felt that special masochistic pleasure that work brings when made while others play. Suddenly I grabbed the cardboard back of a sketch pad and *Actress in Sidelight* just appeared. It was as if I had turned to wave goodbye to the real world from the cockpit of a jet. Filled with guilt on having recidivated into a figurative mode, I tucked the work furtively behind a door and went happily back to space cadeting.

A few days later I looked at the Actress and realized it had set me free. Though art is, as Matisse remarked, a priesthood, I was not prepared to become a verger for any one religion. I would do what I had to do when I had to do it, and would build no bunkers, dig no trenches, and set out no theoretical barbed wire. I thank *Actress in Sidelight* for keeping me out of formalist shelters in the no man's land between the trenches of received opinion and manufactured *angst*.

In art, unlike war, you are meant to die many times; it is a way of living.

Toronto, Ontario

Actress in Sidelight (1952)
Brush, charcoal, ink, gouache, and pastel on cardboard
71.1 × 50.8 cm
The artist, Toronto
Photograph courtesy of Tom Moore, Toronto

Tony Urquhart

b. 1934, Niagara Falls, Ontario

My art school training was as a painter, and I exhibited as a painter from 1954 to 1964. During 1963–64, I travelled in France and Spain. I had been wanting more of a presence in my two-dimensional work and that year I saw much three-dimensional work, most of which was not "art," but nevertheless had the indefinable presence I sought. Things such as scarecrows in Spain or truck scales in France took on an excitement for me that many traditional works in galleries no longer had. I also did a lot of reading and thinking that year. The result was that I returned home as a "thing-maker."

The first boxes I made were started in 1965. They were tiny cubes six inches high that did not open, and they had landscapes painted on all their sides. By 1967, some boxes had grown to six feet in height but they still did not open. They acted as three-dimensional paintings.

In 1967, I went to Europe again. After this time I began to put things like opening altarpieces, baroque cathedrals and *vierge ouvrants* ("opening virgins"— marvelous little hinged sculptures) together with my boxes. This resulted in the opening-box sculptures.

Suddenly I had discovered a work of art that had an interior that could be hidden (or not), that could change its volume, its colour, its texture, and even its gesture, thereby opening up limitless new possibilities.

The base of *The Red Secret* was inspired partly by the Eiffel Tower, also in part by the base of an old electric fan that used to turn in my grandmother's kitchen. The top is directly connected to Catholic confessionals (ergo the title). It has a niche with a sort of sacred stone or pebble and on the opposite side a small rocky cliff confronted with a lump-like shape trimmed with feathers. The whole ensemble seems to be hinting at some sort of mute fetish. I cannot articulate meaning in *The Red Secret* more than this, except to say that in our world we have lost touch with many of the senses we had as more basic or "primitive" people. My work is a groping towards a re-discovery of some of them.

Wellesley, Ontario

The Red Secret (1983)
Oil on plywood and mixed media
170 cm high
The artist, Wellesley
Photograph courtesy of Tom Moore, Toronto

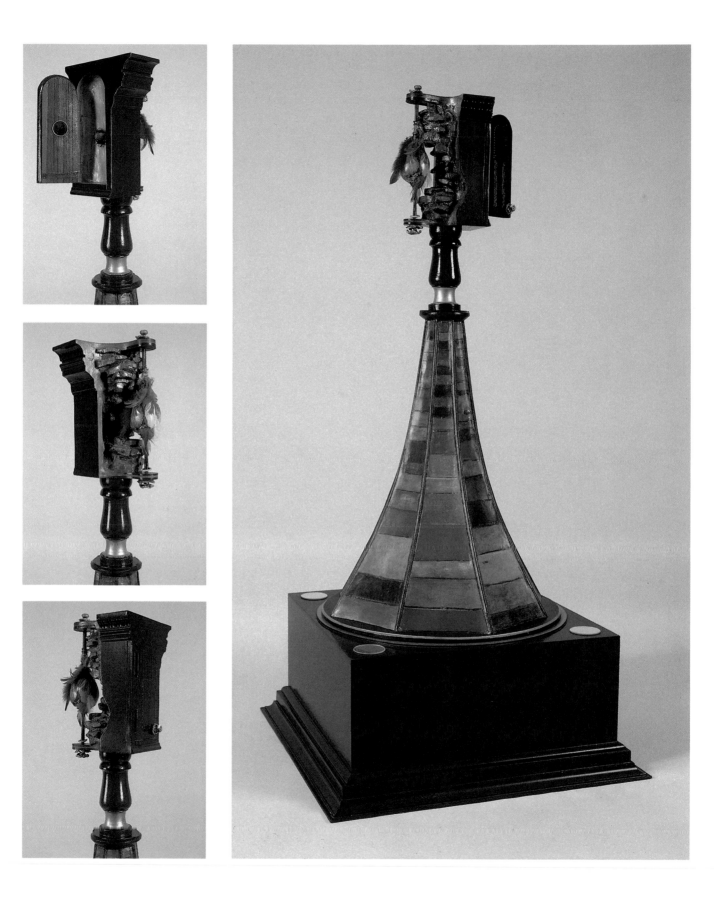

Renée van Halm

b. 1949, Amsterdam, Holland

Based on an anonymous thirteenth-century drawing of the Visitation, this work portrays a portico as a transitional zone between public and private realms. This space functions as a stage where an implied figure becomes conscious of her altered role, hence her implication. This brings to mind the process of rebirth which occurs each time we move from the security of a known situation to one in which we feel vulnerable. The piece is an attempt to crystallize that moment through the presentation of gestural fragments—in this case, feet. The curtain conceals from us any potential clarification of the situation, adding ambiguity and heightening our anticipation.

The subject matter of the original Gothic work, a Visitation, interests me particularly because it represents a confrontation. Mary, approaching from the outside, is about to communicate to Elizabeth, who has just come from the interior, the news of her pregnancy. Elizabeth pauses, and in doing so establishes contact with Mary. In a similar manner the viewer pauses, in the role of Mary, and confronts the work. All hesitate for that split-second.

Two anthropomorphic columns, the only structural support, refer to the Greek caryatids, figures bearing on their heads the weight of the entire roof. Behind the curved curtain, through a narrow opening (implying a distant doorway), we see a "hot" interior. To the right of the main structure, in an adjacent wall, is a small opening, surmounted by an awning, from which a small statue emerges. The disparity in size (the feet and statue are equal in height) causes us to question some basic assumptions about representation. The more complete statue is in fact less "real" than the fragment.

Fragments, in their lack of wholeness, and space, by its nature experiential, place exceptional demands on the viewer. This work is an attempt to engage in a dialogue of part to whole. *In Pausing, She Is Implicated in a Well-Structured Relationship* goes back to an image in early Renaissance art to appropriate its form and content. The meaning and images in the piece are layered so that it is not an architectural monument being read in isolation. The importance of it to me lies in its clarification of my earlier concern and the way it indicated a future direction.

Toronto, Ontario

In Pausing, She Is Implicated in a Well-Structured Relationship (1983)
Acrylic on wood, canvas, and plaster
2.6 × 2.6 × 1.5 m
Montreal Museum of Fine Arts, Montreal
Photograph courtesy of Larry Ostrom, Art Gallery of Ontario, Toronto

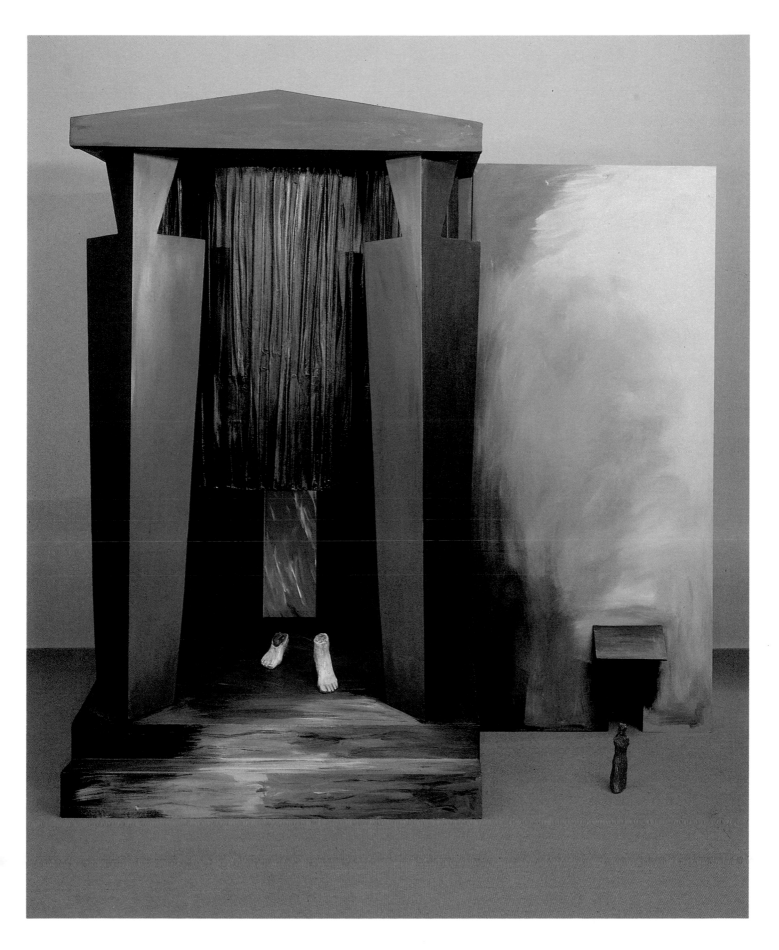

Carol Wainio

b. 1955, Sarnia, Ontario

As the title suggests, *News Fragment* concerns television news. Compared to other works I've done recently, it is small. The central mass of forms could be about the size of a TV screen. I was interested, among other things, in quantitative and qualitative information and in how TV's real agenda always seems to be merely to keep us watching.

The painting started out with the figure on the right, the "subject" of the news report. He occupies a ground which has the qualities of an atmosphere or a space, and he is painted in a manner that emphasizes integral qualities—that is, the few brushstrokes of which he is constructed are not easily separable into the several distinct spatial levels usually found in my figures. The brushstrokes also suggest solidity, echoed by a cast shadow falling on the ground.

One moves from this recognizable figure to the larger mass of forms in the centre. On examination, the centre reveals several figures of the same size and type as the first, multiplied and entangled in a mass of "information." Out of this mass appears another "order" of information, an enlarged dot-matrix image of the head and torso of the subject at right.

To the left of this media subject, and also on the surface, another figure emerges holding a microphone.

This figure, a news announcer standing in three-quarter position, is difficult to identify because he's split into two sections and rendered in a more cursory manner than the others. The edge of him furthest from us is also constructed in dot-matrix fashion and also rests on the surface of the mass of forms. That part of his body closest to us, on the other hand, is split off from that surface and casts a shallow shadow against it. This section (hair, arm, microphone, and thigh) is of a thick, clear, acrylic substance. Fragments of words and images are painted on both the back and front, and at the edges they are seen turning around this transparent substance.

The news announcer looks at this information from one side, we look at it from the other. Somewhere in this transaction, in which the announcer looks at us through a part of him or herself, in which words and images turn, self-contained and referenceless, around a mediating transparent substance—somewhere in this complicity of gazing, split off and resting on the surface, the original subject is lost.

Montreal, Quebec

News Fragment (1985)
Acrylic on canvas
86.0 × 127.0 cm
Lonti Ebers, Toronto
Photograph courtesy of S.L. Simpson Gallery, Toronto

Esther Warkov

b. 1941, Winnipeg, Manitoba

There were silent Jews who spoke no words and whose thoughts were unknown to me.

The man in my drawing appears in a book of photographs by Roman Vishniak. This book documents the lives of the Jewish people in Poland prior to the Holocaust. The man in the photograph carried an empty bentwood chair on his back. Imagine a bentwood chair in 1919 Poland. A chair with legs so delicately curved and with a seat so round that only a beautifully dressed woman would be allowed to sit in it. The empty chair filled my head. I looked at the chair on and off for days and searched for an image to put in it. I found a photo of a woman in a diaphanous gown selling Remy Martin liqueur on the back of the *New Yorker* magazine. She is the man's granddaughter in America. She is also someone whose thoughts are unknown to me. Around her neck was a flowing sash covered with a multitude of coloured stripes. I transformed the flowing sash into the black and white striped pants of the camps. These pants with protruding feet are trying to escape their inevitable fate. The man did not see me drawing him and is completely unaware that I am turning him into a rooster. He would not be pleased to know that I am performing a magic ritual on him. In this town in 1919 I would not have been allowed to perform magic rituals, except perhaps to kosher the occasional chicken. The man does not know that his granddaughter is sitting on the chair. He does not look backwards or up or down as he slowly walks to the left-hand side of the drawing and therefore he cannot see the future below him.

The work is important to me because I grew up in a house of silence and I want to give that house a voice.

Winnipeg, Manitoba

Memories for the Future (1985)
Graphite and coloured pencil on paper
39.5 × 50.9 cm
Grace and Ted Goldberg, Toronto
Photograph courtesy of Ernest Mayer, Winnipeg

Colette Whiten

b. 1945, Birmingham, England

Although this work no longer exists, I selected it as critical to my development.

This work opened up an area of exploration that allowed me to test my thoughts and feelings about personal relationships and their boundaries. Gauging oneself, both literally and metaphorically, against material and the people we come in contact with were also important considerations.

The focus on the negative space acknowledged that, individually, we have an effect on people and things that we are responsible for. I was able to let go of the unwieldy documentation of process, as the empty space encouraged empathy from the viewer.

Each piece of work serves to expand or increase our personal vocabulary. Occasionally we manage to create a work that makes tangible the desire to understand.

Toronto, Ontario

Snow Sketch (1975)
Snow
Life size (work no longer exists)
Photograph courtesy of the artist, Toronto

189

Irene F. Whittome

b. 1942, Vancouver, British Columbia

Take linear time, ritual time, and repetitive time and construct an assembly. The grid becomes the unifying principle, the topic

1) Ritual time, a command to stick pins
2) Linear time, the notations of a musical composition
3) Repetitive time, a set of lines on library cards

With this assembly one has a set of rules for transforming. Visions are recorded.

Thoughts about Paperworks I
And then TIME, for me, is not that unimaginable thing that never stops.

Time...
- Desire for activity (even manual)
- Desire for calm, clear, sober thought
- Walls of my room repapered, covered them with dates

Dates...
- The dates overlaid displayed every variety of colour
- Each found appropriate expression in the vibrance of its colour, making the colours of the preceding one pale before it
- If dates could repeat themselves, I should be able to begin a new life
- With a little imagination each of them might be adapted to a good resolution

Numbers...
- Certain numbers sounded as if each number doubled the one before
- Certain numbers gave me a moment's pause

Paperworks I...
- Some seemed to be missing
- Certain arrested my attention by their very inconsequence
- Each had their own rhythm
- Each number in turn contradicts the one that went before
- Certain numbers deserved to be celebrated (by custom)
- An attitude of preservation for eventual renewal
- *Write it away*, and you will see how you begin to get a clear picture of yourself

Montreal, Quebec

Paperworks I (1977)
Installation in Yajima Gallery, Montreal
Included in installation:

Irish Medley (1977)
Paper mounted on cardboard, graphite, ink, masking tape, pins, cloth
243.8 × 91.4 cm
National Gallery of Canada, Ottawa

318, 319, 320 (1977)
Paper, masking tape, pencil, pins, composition board applied to backboard
61.0 × 121.9 cm
Vancouver Art Gallery, Vancouver

Photographs courtesy of Gabor Szilasi, Montreal

Joyce Wieland

b. 1931, Toronto, Ontario

One day, while downstairs, I felt the need to start a painting. I felt as if I was on fire. I ran upstairs and started a fresh canvas that was on the easel.

I painted a woman painting out of doors. I painted a male angel, but didn't really like him; then an older man with a beard; then a more Italian or Greek sort of man. None of these seemed right. Finally I arrived at a figure who seemed to be a sort of hero. He looked a lot like Napoleon and wore a laurel wreath. I found him so attractive that I painted him in a state of sexual arousal.

Although the woman in the canvas is an artist, and seems to be me, she finally began to look like Madame Pompadour, with her familiar hair style. The flames coming out of her back portray the way I felt when I was painting her picture. The painting is really about creative fire and sexual fire.

The setting seems to be at Versailles. I enjoy putting myself into a historical context and acting out history as a character in my paintings. Not that this happens all the time; but when it does, I take great pleasure in playing that part.

Toronto, Ontario

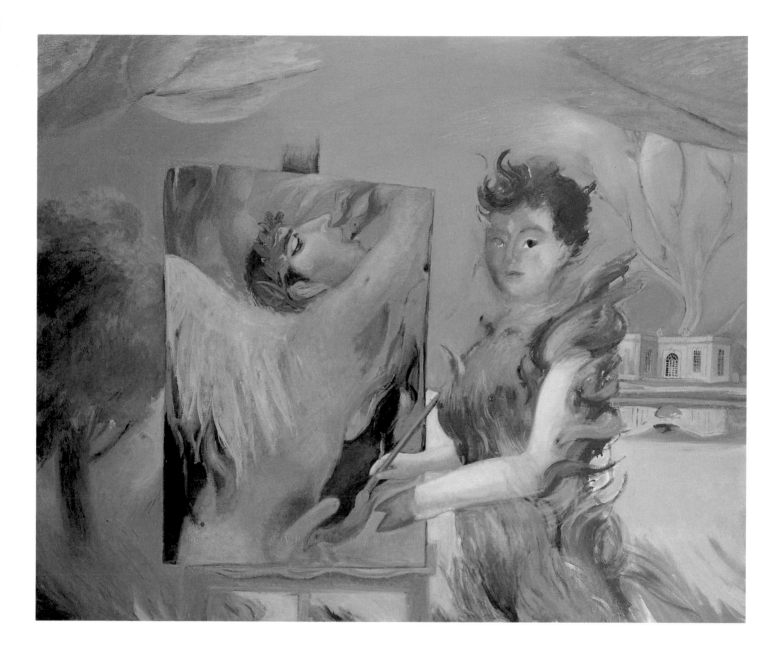

Artist on Fire (1983)
Oil on canvas
106.7 × 129.5 cm
Robert McLaughlin Gallery, Oshawa
Photograph courtesy of Tom Moore, Toronto

Jan Winton

b. 1954, Toronto, Ontario

My art has always been an extension of an inner dialogue. It is only since I began to use photography within the image that I've felt able to bring the outer (conscious) dialogue into the work. My choice of medium in each separate work is based on this. I see narrative as a prop, whose real function is to support the description of sensation. The camera functions as a tool, much like visual memory, giving me access to random subjects. I find that the print medium offers me a lot of flexibility. As with other media, its strengths are specific to the intellectual and emotional choices of the artist, with the key difference being the opportunity to repeat and reaffirm the visual choices that have gone into the production of the work. There is a ritualistic element to printmaking which physically divides and reunites thought.

The Shadow Dance is about the inner and outer dialogue to which I have referred. Here the topic is action and reaction. By placing my figure in the window, I look out on the world; I also look back into the room.

The chair beside me has been manufactured by someone because of our (my) ability to sit; and in its very form, pillow in place, it invites my body to conform to its shape. The Dancer in the foreground is frozen in movement, as though to question; with one arm dramatically raised the other arm moves in an unconscious gesture of defence. I look at myself through the clear and conscious eyes of the figure in the window and glance back through the emotional haze of the dancer. It is not important that the viewer know the figures are myself. I employ myself within the image as a stereotype in order to ask the shared questions we ask ourselves...about strength and vulnerability, passivity and aggression, perception and reality.

Toronto, Ontario

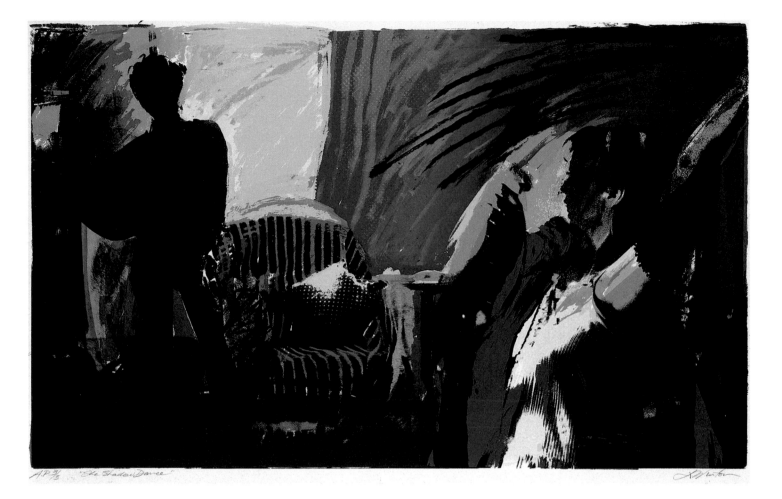

The Shadow Dance (1986)
Serigraph on Arches Cover Paper
Image size 60.0 × 97.1 cm
7/15
Printed at Open Studio, Toronto
The artist, Toronto
Photograph courtesy of Ross Wahl, Toronto

Hilda Woolnough

b. 1934, Northampton, England

Generally people still think of drawing as a minor art: as a prelude to painting or sculpture or architecture. They are prepared to pay more for a painting despite the fact that a drawing on rag paper protected from strong sunlight will probably last longer than paint on canvas. Many critics are unwilling to give to an exhibition of drawings the same amount of attention that they devote unstintingly to paintings.

My latest exhibition, *Fishtales*, is a very complex installation. The viewer has to make a leap of imagination into the future, where the work exhibited belongs to a post-nuclear museum. It is assumed that the curator (or curators) has/have pieced together fragments of knowledge about a vanished society: fragments from historic sites, and from memories of descendants of survivors.

The drawings fall into four series: Genesis, the Narrative, the Gift-bearers, and the Codices. *The Mating of Seaman* comes from the Narrative. You are not sure whether Seaman's orgasm is horrifying or pleasurable. Seawomb (fishwomb) by contrast, is very much herself: very contained. Another drawing shows Seaman wearing a Fishmask. Here once again you encounter visual ambivalence: the contrast between the masked head and the perceived, perceiving face beneath is frightening. By comparison, in Seawomb feeding Season, Seaman is a tiny white squirrelly termite between two huge grindstones, his gigantic blimp of a mother and the equally massive turtle.

In the Gift-bearers and the Codices I wanted to show the beauty and the precious aspects of nature. The finely detailed, brilliantly coloured technique in these (often postage-stamp-sized) drawings is totally different from that of the Narrative. In the Narrative I used frottage, a technique that I've been investigating and refining for a long time now. Another means is reduction; not a technique I use as much as frottage, but here—with the Narrative—it seemed appropriate. That's how you get a faceted, undulating white. What I did with the black I learned from Van Gogh. In his diary, Van Gogh writes about doing tests with milk and graphite. I did tests myself to see what happened when the graphite absorbed the milk—that is, the milk and water mixture. I thought the drawings would go yellow but they haven't so far.... Anyway, this time I didn't use milk. Instead I polished the graphite as I'd done in the experiments. And what this burnishing did was to bring the graphite to an unbelievably rich, velvet black. It's almost like eternity, that black.

Breadalbane, Prince Edward Island

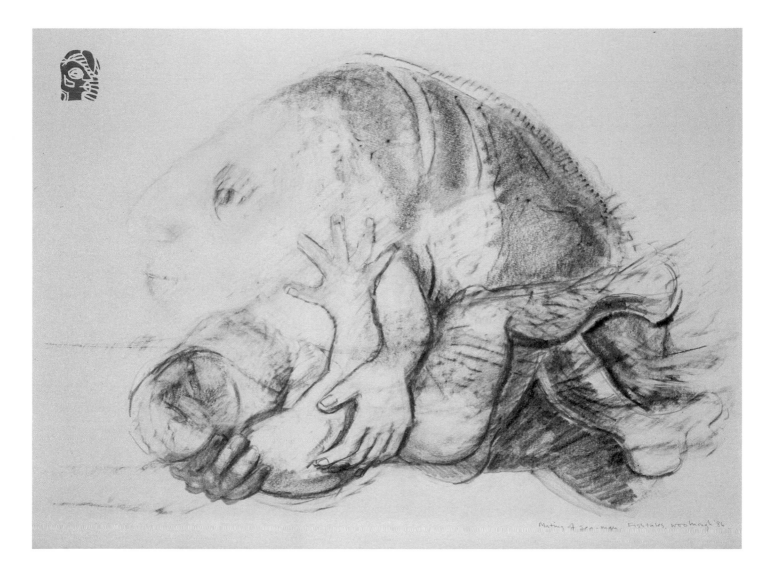

The Mating of Seaman (1986)
Graphite on paper
55.9 × 76.2 cm
Jennifer and David Whittlesey, Charlottetown
Photograph courtesy of the artist, Charlottetown, and Tom
Moore, Toronto

Alex Wyse

b. 1938, Tewkesbury, England

This was a combination of my two worlds—I have always wanted to make people laugh and to combine my storytelling with sculpture. This time, although I delight in fancying things up, adding characters, frills, words, I thought, "My God! I've got guts enough. I'm going to just damn well do it and I'm just going to leave it."

At one time, one thought of rockets as exciting and romantic. Or there were the rockets the Chinese developed. Now our rockets have a horrible odour and go into space. A rocket's a strange thing when you think it's a sudden W-H-O-O-S-H and they all sparkle. They can be dangerous. My aunt had a rocket fall on her head. My rocket's a fun thing with a serious tone because I'm trying to discipline myself in my art form. On my rocket there are four cables to hold the rocket down. I'm not so sure we should release the rocket, however grand and gorgeous it is. We should have time to contemplate what we are releasing a rocket for. It should go up into a glorious display and not be used for secret missions. I'm saying let's hold it as well as (perhaps) I'm holding my own art.

Ottawa, Ontario

Rutherford Rocket (1986)
Wood, metal, nails, paint
205.0 × 33.0 × 33.0 cm
Lucy and Stefan Grossman-Hensel, Ottawa
Photograph courtesy of The Agnes Etherington Art Centre, Kingston, and Larry Ostram, Westport

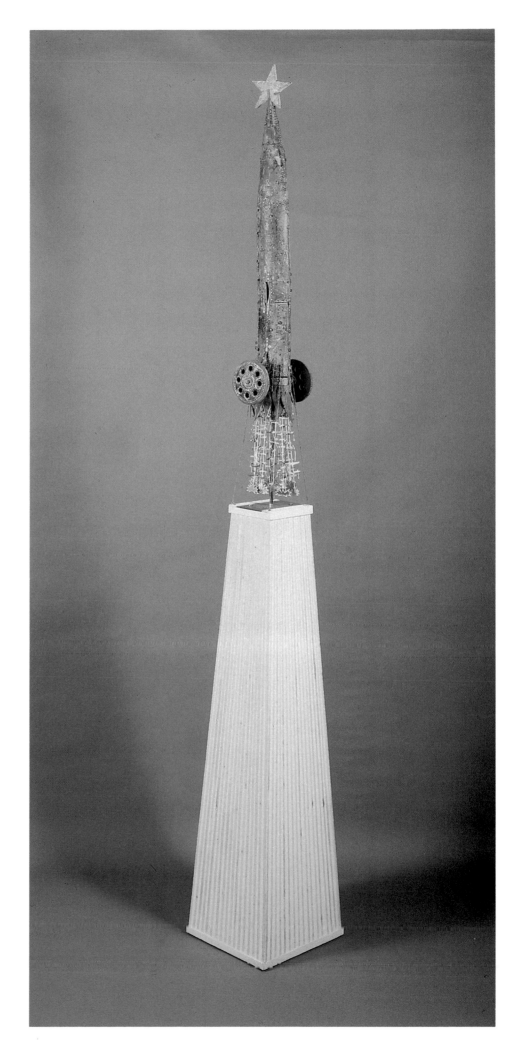

Ed Zelenak

b. 1940, St. Thomas, Ontario

Eye, I Level at Six Feet summarized issues which have been fundamental to my activity during the past few years. As sculpture, it addresses the nature of perception, relational order, and language. Two primary forms face each other. Configuration "Eye" functions as symbol, a metaphor for the act of seeing. Configuration "I" represents sign, a subjective extension of the self.

The locale of each form is determined by a line projected from core point "Eye" to the tip of form "I," which is six feet in height. Form "I" itself is seen as totem; vertical, as a mode of measurement indicating man's relationship to the earth, divided graphically into horizontal and vertical segments indicating latitude and longitude. Vertical posture is a symbol for an inner condition, determining the viewpoint from which we perceive the world. Man is the focal point of all perceptions.

Eye, I Level at Six Feet in the form of a double image postulates the notion that if sign and symbol operate on continuous parallel planes, the work could be considered as an ordered and finite text. As an object of the world, the sculpture is spatial, but the linear order of the events that occur in determining the structure of the work reflects a temporal element in operation. *Eye, I Level at Six Feet* is a metaphor for the self, in terms of perceiving a position occupied relative to our physical and psychological centres.

West Lorne, Ontario

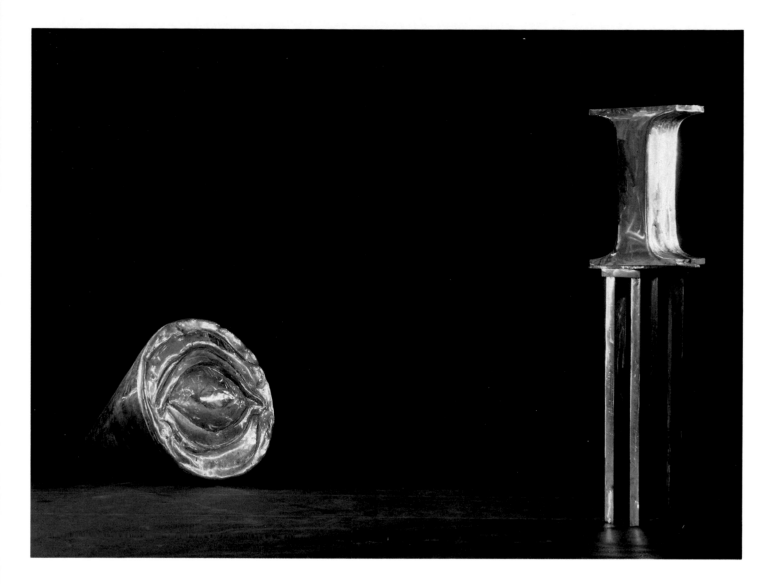

Eye, I Level at Six Feet (1984–86)
Carved steel blued and oiled
Two pieces: 91.4 cm high × 137.2 cm deep; 182.9 cm high ×
61.0 cm deep
The artist, West Lorne
Photograph courtesy of Randy Dunlop, London

Edited by José Druker
Designed by David Shaw/Bookends East
Composed by Attic Typesetting Inc.
Manufactured by Friesen Printers, Altona, Manitoba